William Merritt Chase
Summers at Shinnecock 1891–1902

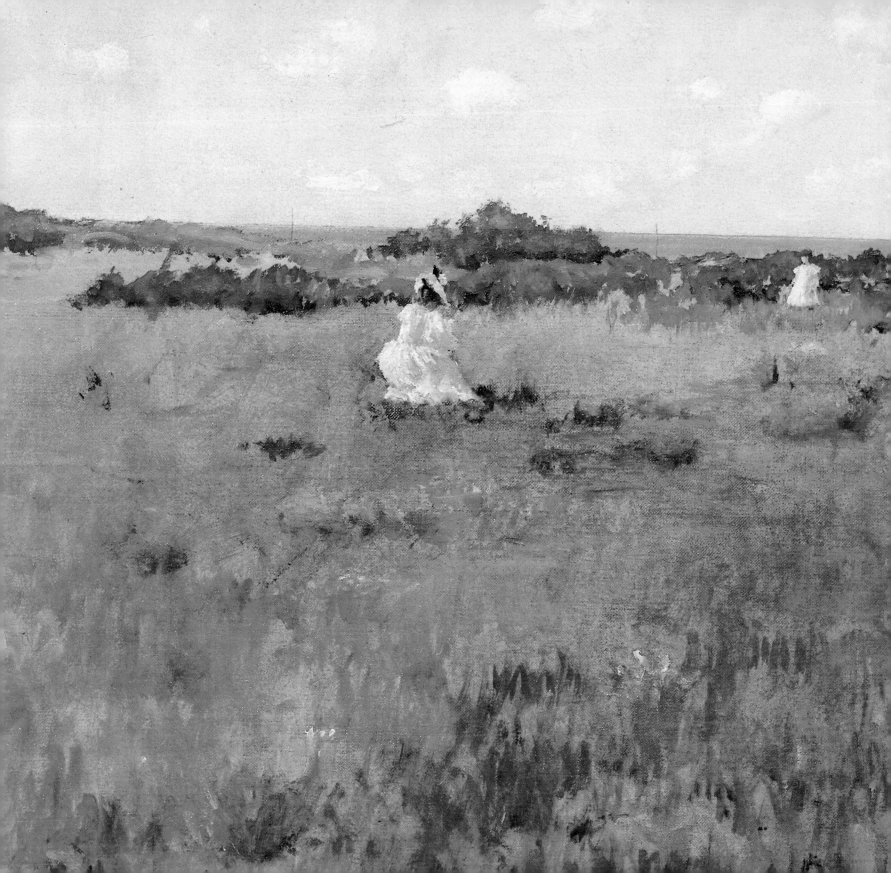

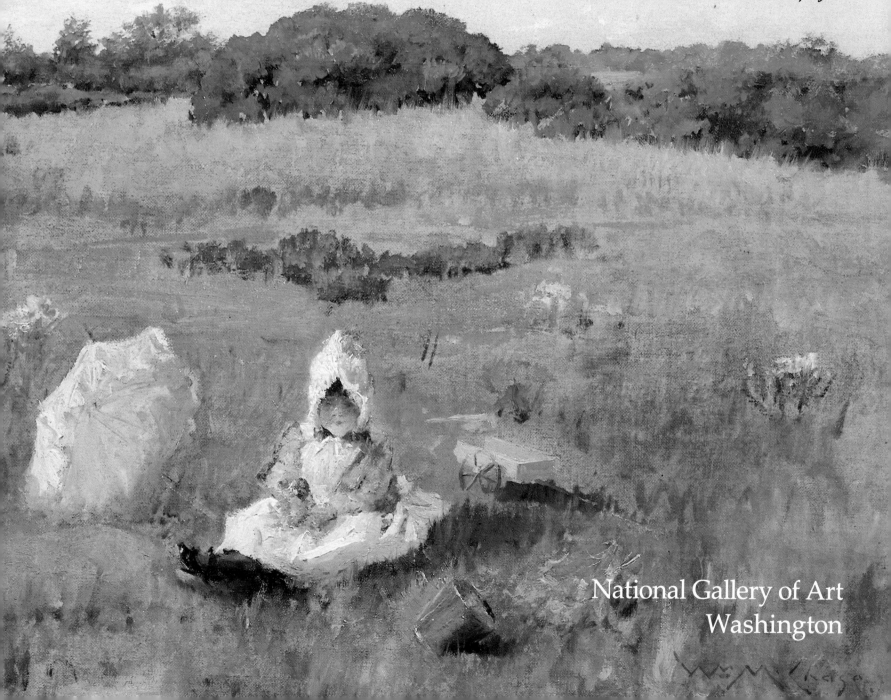

William Merritt Chase
Summers at Shinnecock 1891–1902

D. SCOTT ATKINSON NICOLAI CIKOVSKY, JR.

National Gallery of Art
Washington

The exhibition at the National Gallery of Art is supported by Bell Atlantic

EXHIBITION DATES

National Gallery of Art, Washington
6 September–29 November 1987

Terra Museum of American Art, Chicago
11 December 1987–28 February 1988

This catalogue was produced by the Editors Office, National Gallery of Art, Washington.
The type is Palatino, set by Columbia Publishing Company, Inc., Baltimore, Maryland.
Printed by Village Craftsmen, Rosemont, New Jersey, on Vintage Velvet paper
Designed by Chris Vogel
Edited by Jane Sweeney

PHOTO CREDITS: All colorplates reproduced courtesy of the works' owners with the following photographers credited: Nathan Rabin (pl. 17); Noel Rowe (pls. 4, 24); John Tennant (pl. 19).

Universe Books, distributed to the trade by St. Martin's Press
381 Park Avenue South
New York, N.Y. 10016
ISBN 0–87663–539–7

Library of Congress Cataloging-in-Publication Data

Cikovsky, Nicolai.
 William Merritt Chase : summers at Shinnecock 1891–1902.
 Catalog of an exhibit held at the National Gallery of Art, Washington, Sept. 6–Nov. 29, 1987, and at the Terra Museum of American Art, Chicago, Dec. 11, 1987–Feb. 28, 1988.
 Bibliography: p.
 1. Chase, William Merritt, 1849–1916—Exhibitions. 2. Landscape painting, American—Exhibitions. 3. Landscape painting—19th century—United States—Exhibitions. 4. Shinnecock Hills (Long Island, N.Y.) in art—Exhibitions. 5. Impressionism (Art)—United States—Exhibitions. 6. Shinnecock Summer School of Art—Exhibitions. 7. Painters—United States—Biography. I. Atkinson, D. Scott, 1953– . II. Chase, William Merritt, 1849–1916. III. National Gallery of Art (U.S.). IV. Terra Museum of American Art. I. Title.
ND237.C48A4 1987 759.13 87–13097
ISBN 0–89468–103–6

FRONT COVER: Detail, *Untitled (Shinnecock Landscape)*, about 1892. The Parrish Art Museum, Southampton

BACK COVER: Detail, *A Friendly Call*, 1894 or 1895. National Gallery of Art, Washington, Chester Dale Collection

TITLE PAGE: Detail, *Gathering Autumn Flowers*, 1894 or 1895. From the Collection of Mr. and Mrs. Paul Mellon, Upperville, Virginia

Contents

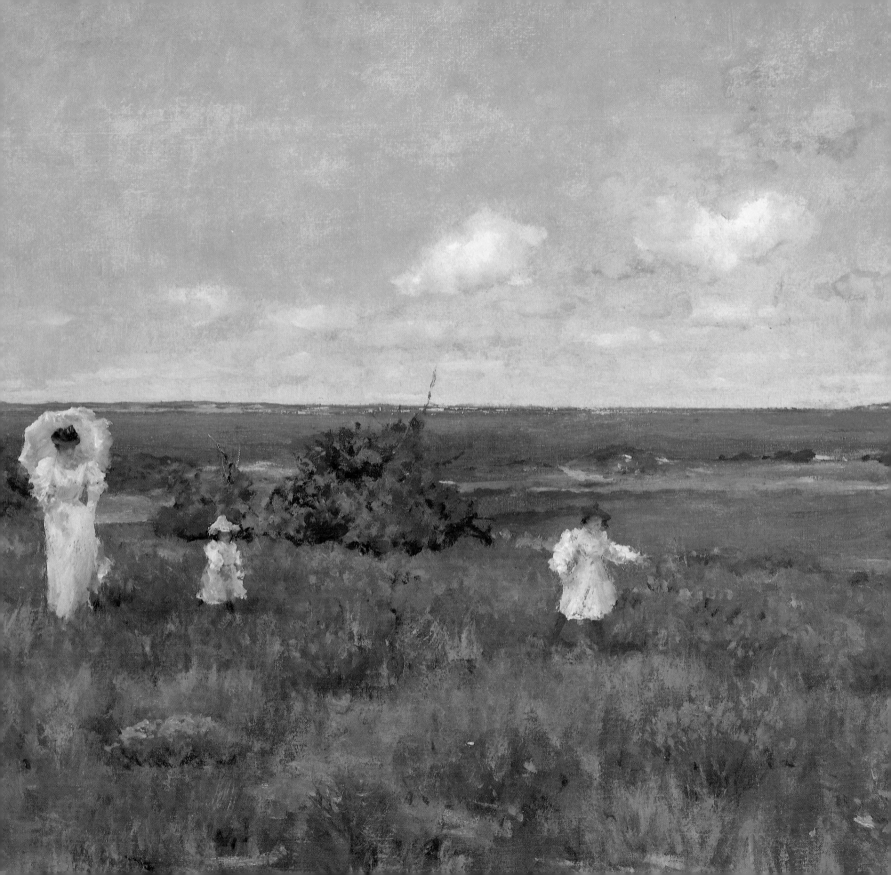

Foreword

THE LANDSCAPES AND INTERIORS THAT William Merritt Chase painted in the 1890s during his summers at Shinnecock, on eastern Long Island, are his finest single achievement, and some of the most purely beautiful and thoroughly delightful pictures painted in late nineteenth-century America.

Summers at Shinnecock is the first exhibition of Chase's Shinnecock paintings. It is also the first collaborative undertaking of the National Gallery of Art with the Terra Museum of American Art in its new incarnation on Chicago's Michigan Avenue. The exhibition was conceived jointly by Nicolai Cikovsky, Jr., curator of American art at the National Gallery, and Daniel J. Terra, founder and chairman, and D. Scott Atkinson, curator, of the Terra Museum. We commend them all.

Summers at Shinnecock is the inaugural exhibition of a three-part series of masters and masterpieces of American impressionism supported at the National Gallery by Bell Atlantic. We are grateful for their generous and far-sighted sponsorship.

No exhibition would be possible without the sacrifice and trust of its lenders. For them we reserve our warmest thanks.

J. Carter Brown
Director
National Gallery of Art

Michael Sanden
Director
Terra Museum of American Art

OPPOSITE PAGE: Detail, *Near the Beach, Shinnecock*, about 1895. Toledo Museum of Art; Gift of Florence Scott Libbey

7

Lenders to the Exhibition

Mr. and Mrs. Arthur Altschul

The Butler Institute of American Art, Youngstown

Amon Carter Museum, Fort Worth

Jamee and Marshall Field

Georgia Museum of Art,
The University of Georgia, Athens

Henry Art Gallery, University of Washington, Seattle

The Hirshhorn Museum and Sculpture Garden,
Smithsonian Institution, Washington

Mr. and Mrs. Raymond J. Horowitz

Mr. and Mrs. Paul Mellon

The Metropolitan Museum of Art, New York

Murjani Collection

National Gallery of Art, Washington

National Museum of American Art,
Smithsonian Institution, Washington

The Parrish Art Museum, Southampton

The Shearson Lehman Brothers Collection

Terra Museum of American Art, Chicago;
Daniel J. Terra Collection

The Toledo Museum of Art

Private collectors

Preface

SUMMERS AT SHINNECOCK RESULTS FROM the complementary ambitions of the National Gallery to do a series of exploratory and explanatory exhibitions focusing on works of special importance in the Gallery's American collections, and of the Terra Museum to launch an exhibition program highlighting works in its collection.

Chase's Shinnecock paintings are a distinct, self-defined group within Chase's work as a whole. They have a common subject, of course, and were made during the years—1891 to 1902—that Chase summered at Shinnecock. But they are also consistently the most lovely, most moving, and most assured works that Chase ever made—for something special about his summers at Shinnecock inspired Chase's finest creative achievement.

This is the kind of exhibition—its subject clear, the quality of its objects uniformly high—that can be said to have very largely chosen itself, or at least to have made what can often be troublesome curatorial choices relatively simple and confident. Nevertheless, it could not have been done without many, many people who were helpful in a variety of ways.

Everyone who works on Chase today must rely on the indispensable scholarship of Chase's foremost modern interpreter, Ronald G. Pisano. We are hugely in his debt. The advice, counsel, and good offices of many others, given freely and abundantly, was critically important. On Long Island, James J. Harmon, the present owner of Chase's house and studio at Shinnecock, allowed us to prowl the premises freely, and Frank Zaperach took valuable time to arrange and escort us on our visits. Trudy Kramer, director, Maureen O'Brien, associate director for cultural affairs, and Alicia Longwell, registrar, all of the Parrish Art Museum, Southampton, liberally gave access to the unrivaled collection of Chase material in their care, handled

our questions with patience, and viewed our loan requests sympathetically. Robert Keene, historian, Town of Southampton, and Dorothy T. King, librarian, Long Island Collection, East Hampton Free Library, gave freely of their special knowledge.

Raymond and Margaret Horowitz (who appear elsewhere as lenders to the exhibition) shared their contagious enthusiasm and deep knowledge of Chase. Lawrence A. Fleischman, president, Kennedy Galleries, Inc.; Daniel B. Grossman; James Maroney; M. P. Naud, director, department of American art, Hirschl & Adler Galleries; David Nissinson; Donna Seldin, of the Coe Kerr Gallery, Inc., and Robert Schonfeld all helped in locating Chase's Shinnecock work.

Professor William A. Coles went to a great deal of trouble to provide essential photographs of Alfred Stevens' paintings, and Mr. and Mrs. Wayne Morrell, who supplied photographs of Chase's Shinnecock studio, were generous and hospitable in equally large measure. Mr. and Mrs. Thomas A. Rosse, at a very inconvenient time, kindly showed their fine painting, which a conflicting obligation excluded from this exhibition.

Jane Sweeney and Chris Vogel of the National Gallery's editors office edited and designed the catalogue with an art concealed by art. Dodge Thompson, director of exhibitions at the National Gallery, and Debbie Shepherd, of the Gallery's department of exhibitions and loans, oversaw every detail of the exhibition with the greatest care, tact, and foresight. Gaillard Ravenel and staff installed the exhibition with a perfection that is second nature to them all. In the American art department, Rosemary O'Reilly saw to the necessary writing, filing, telephoning, and traveling faultlessly and unflappably.

At the Terra Museum Robin Franklin was resourceful in her research for the landscape essay, and Barbara D. Hall was unfailing in her assistance in its production. Louise Brownell capably coordinated the details that the exhibition demanded of the registrar's office, and museum preparator Richard Graham installed the paintings with great care. The museum acknowledges the contributions made by all staff members whose participation was essential in bringing the exhibition to Chicago.

D. S. A.
N. C. Jr.

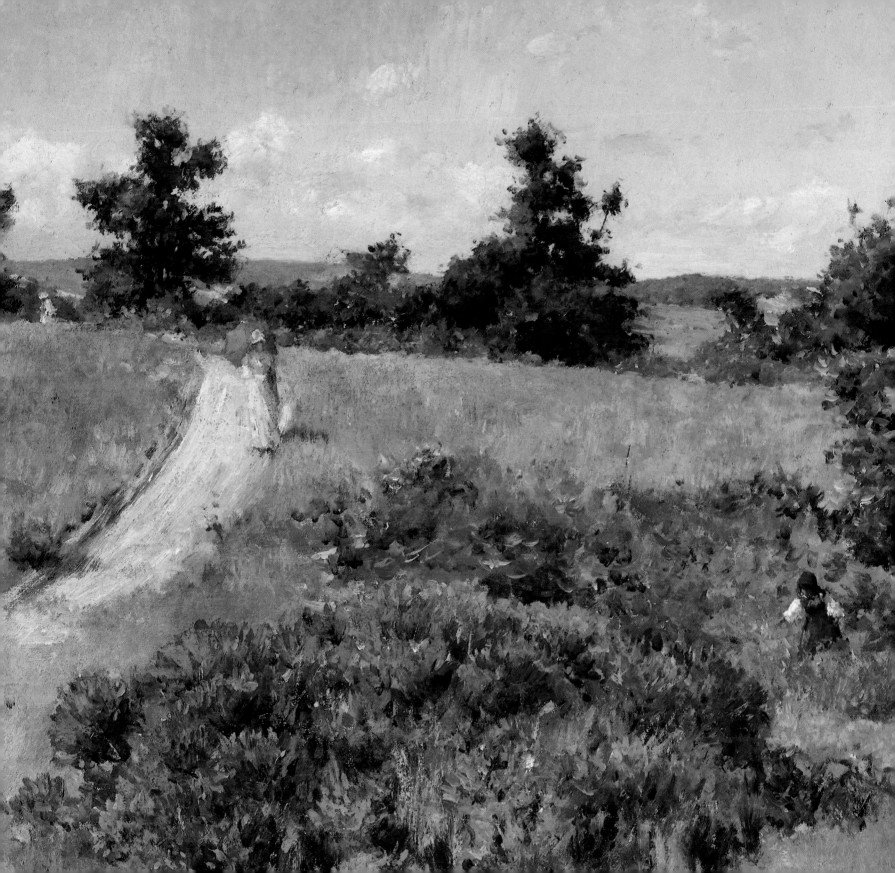

Shinnecock and the
Shinnecock Landscapes

D. SCOTT ATKINSON

In 1878, AFTER SIX YEARS OF STUDY in Munich, William Merritt Chase returned to America and quickly established himself as one of New York's most prominent painters. In the ensuing years his reputation as a portrait, figure, and still-life painter grew considerably, as did his fame as a teacher. But it was only in the 1890s, during the summers he spent at Shinnecock Hills, an area of barren sand dunes that covered some 3,800 acres of the Town of Southampton on eastern Long Island, that landscape became a significant part of his work. In a decade of summers at Shinnecock, Chase not only created a lasting visual record of this small part of Long Island, but in so doing also produced some of the finest impressionist landscapes executed in America.

Chase's Life: Early and Middle Years

Chase was born in 1849 in Williamsburg, Indiana, the oldest child of a successful merchant. In 1861 the family moved from Williamsburg to the rapidly growing city of Indianapolis, where Chase received his first artistic training. In 1867, his early fascination with pictures and a predilection for drawing convinced his father that he deserved a proper artistic training, and Chase was apprenticed to a local painter, Barton S. Hays. He remained with Hays for two years, learning chiefly to paint still life. Then, on Hays' advice, his father sent him to New York for further training. Chase enrolled at the school of

OPPOSITE PAGE: Detail, *Shinnecock Landscape with Figures*, about 1895. Murjani Collection

the National Academy of Design, and, to support himself, painted still lifes, which brought him critical and financial success throughout his life.

In 1871 Chase moved to Saint Louis, where his family had relocated. There he established himself as a still-life painter, but with little success. His fortunes changed when he was befriended by two prominent local businessmen and art patrons. Taking an active interest in Chase's career, they decided to finance his study in Europe. He enrolled at the Munich Royal Academy in the fall of 1872, studying with its director, Karl von Piloty, under whose guidance the academy's teaching stressed a tenebrous, bravura style derived largely from the Dutch and Spanish masters of the seventeenth century, Hals, Rembrandt, and Velázquez.

Chase's reputation as a painter preceded his return to New York in 1878, and a teaching position at the newly established Art Students League awaited him. He taught at the league until 1896, the first post in what would be a distinguished and lifelong teaching career. Chase's place as one of New York's most prominent painters was established not only by the character of his art, but also by the studio he acquired in the Tenth Street Studio Building. Adorned with paintings, tapestries, objects of art, and bric-a-brac that Chase collected omnivorously, the studio became a gathering place for artists, students, and patrons, and the showcase for

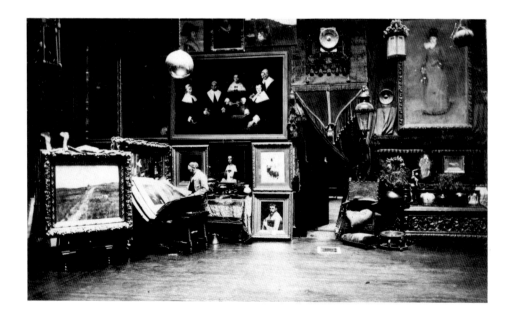

Fig. 1. Chase's Tenth Street Studio, interior, about 1895. The Parrish Art Museum, Southampton, William Merritt Chase Archives, Gift of Jackson Chase Storm, 1983

Chase himself (fig. 1). In recognition of Chase's prominence, and of the novelty of his art, Chase was elected in 1880 to a one-year term as president of the Society of American Artists, founded in 1877 to represent advanced art in its struggle with the conservative National Academy of Design. In 1885 he was again elected president of the society, serving for the next decade.

The late 1870s and 1880s was a productive period for Chase. In 1886 his professional success was complemented by the happy event of his marriage to Alice Gerson.

Shinnecock Hills: History and Topography

Great Peconic Bay divides eastern Long Island into the north and south forks (fig. 2). Shinnecock Hills lies at the westernmost end of the south fork, immediately adjacent to the village of Southampton to the east. Great Peconic Bay bounds Shinnecock on the north, and Shinnecock Bay bounds it on the south. The land that became the Town of Southampton, including Shinnecock Hills, was acquired in a treaty from the Shinnecock Indians by English settlers who had come there by way of Lynn, Massachusetts, in 1640. Southampton is the oldest English settlement in New York State.

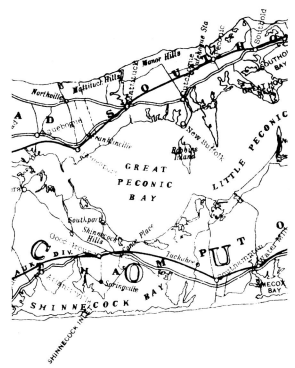

Fig. 2. BOTTOM: *Map of Long Island* (Lain & Co., Brooklyn, 1901). TOP: Detail. Courtesy Library of Congress, Washington, Map Division

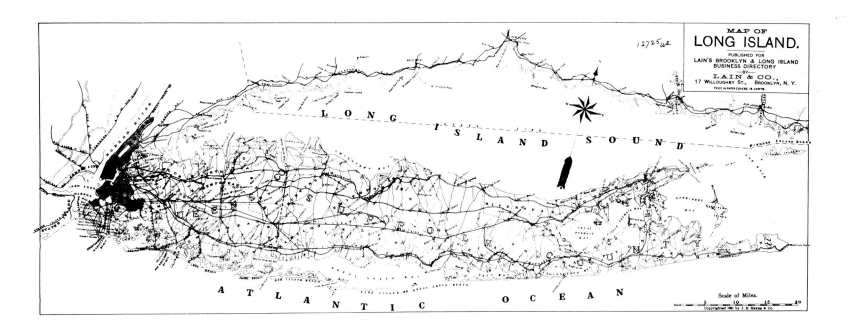

The treaty of 13 December 1640 stipulated that the Shinnecock Indians would retain the land

> . . . from the place commonly knowne by the place where the Indians hayle over their canoes out of the North [Peconic] bay to the south side of the Island from thence to possess all the lands lying Eastward between the foresaid bounds by water, to wit, all the land pertaining to the parteyes aforesaid, as also all the old ground formerly planted lying Eastward from the first creek at the Westemore End of Shinnecock plaine. . . . It is agreed that the Indians above named shall have liberty to break up ground for their use to the westward of the creek on the west side of the Shinnecock plaine.[1]

The treaty of 1640 established the boundaries of Shinnecock as they exist today. The creek mentioned is Heady Creek, which marks the southern boundary. The western boundary, now known as Canoe Place, is the narrowest place between the Great Peconic and Shinnecock bays, and allowed the shortest passage across the fork. The two bays are now joined at the same spot by the Shinnecock Canal, opened in 1897.

The nearly four thousand acres that make up Shinnecock Hills were considered of little value by the early settlers. They regarded the sand dunes covered with wire grass and scrub brush—the "hills" in the otherwise flat landscape—as suitable only for grazing sheep.

Chase's arrival at Shinnecock coincided closely with the commercial development of the region. If the area was of little practical agricultural use, by about 1890 it began to be settled by those who perceived greater but very different value in it. A booklet published by the Long Island Railroad described the place and the state of its development in 1890, the year before Chase's arrival:

> It is hardly possible to imagine a more desirable location for a summer residence. The land is high, and from this rounded plateau one looks down upon one of the finest marine views on the Atlantic coast. The ocean, flecked with sails, is before, while behind, the winding waters of Peconic Bay, with the intermingling shores, give infinite variety of scene. Art has added to Nature's charms in the cottages that have been erected, representing the quaint English architecture of the period of Queen Anne. These "Hills" were purchased by the Long Island Improvement Company, and the finest portion has been transferred to the Shinnecock Inn and Cottage Company, representing prominent New York gentlemen, who have erected a hotel in exact reproduction of an old English inn, and they and other parties have built cottages and made green lawns and gardens where before were sand-heaps and low underbrush. . . . The depot of the Long Island Railroad is in keeping with the style of architecture of the hotels and cottages.[2]

Another aspect of its development was the opening in 1891 of the Shinnecock Hills Golf Club as the first incorporated golf course in America—for if

some thought English architecture appropriate, others, noting Shinnecock's similarity to Scotland, saw that it was also appropriate for golf. But the real estate of Shinnecock had aesthetic as well as commercial and recreational value. "No greater profusion of material can be found anywhere to delight the eye of an artist, in spite of the fact that the whole of Shinnecock can hardly boast of one tree,"[3] one writer said, for, as another explained, "all an artist has to do is to take out his easel and set it up anywhere, and there in front of him is a lovely picture."[4] Still another suggested that Chase's presence certified the beauty of the place: "Of the beauties of the Shinnecock hills and the surrounding country I think it unnecessary to speak. It is enough of a recommendation for them to have [been] chosen as the summer home of an artist like Mr. Chase."[5]

The Shinnecock Hills Summer Art School

New Yorkers escaping the summer heat began arriving on Long Island's south fork as early as 1870, when the Long Island Railroad came to Southampton. One of the earliest summer residents, Mrs. William Hoyt, is credited with the idea of establishing a summer art school at Shinnecock. Herself an amateur painter, Mrs. Hoyt had been impressed by the open air landscape painting she had seen on her extensive travels in Europe. It was training in that form of modern landscape that Mrs. Hoyt wished to provide at Shinnecock. To direct the venture, she turned to Chase. He was not only among the most prominent painters of his generation, and an inspiring and experienced teacher; he had also, in a series of paintings made in Central Park in New York and Prospect Park in Brooklyn in the late 1880s, produced some of the freshest, most brilliant outdoor painting in America. Mrs. Hoyt first approached Chase in 1890, and he conducted the first classes in 1891. To aid the undertaking she enlisted the financial support of two other prominent Southampton residents, Mrs. Henry Kirke Porter and Samuel L. Parrish. They provided the land upon which the large studio building surrounded by a group of residential cottages known as Art Village was built. Several miles from Art Village was the house and studio designed by Stanford White into which Chase and his family moved in 1892, the second summer at Shinnecock, and in which the Chases spent the subsequent summers.

In the summer of 1891 easels began to appear on the Shinnecock dunes as students busily painted the landscape under Chase's guidance and crit-

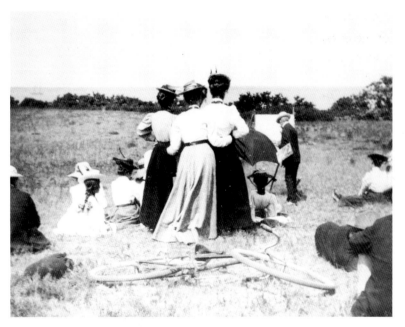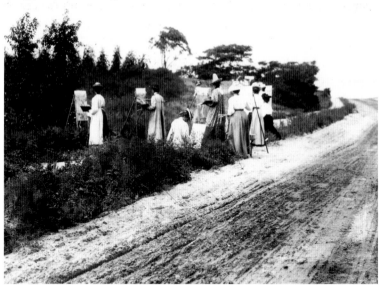

icism (figs. 3, 4). The Summer Art School at Shinnecock was not the first to provide outdoor instruction in America. But it was from the start the largest and most famous. Most of the students—there were about a hundred of them each summer—were amateurs, but important professional artists like Joseph Stella, Rockwell Kent, and Charles Hawthorne also studied with Chase at Shinnecock Hills.

Chase described his principles and practice of outdoor painting in 1891, after his first summer of teaching at Shinnecock:

> I carry a comfortable stool that can be closed up in a small space, and I never use an umbrella. I want all the light I can get. When I have found the spot I like, I set up my easel, and paint the picture on the spot. I think that is the only way rightly to interpret nature. I don't believe in making pencil sketches and then painting your landscape in your studio. You must be right under the sky. You must try to match your colors as nearly as you can to those you see before you, and you must study the effects of light and shade on nature's own hues and tints. You must not ask me what color I should use for such an object or in such a place; I do not know until I have tried it and noted its relation to some other tint, or rather if it keeps the same relation and produces on my canvas the harmony which I see in nature.[6]

Chase taught on Mondays and Tuesdays—"Chase Days."[7] The routine of instruction began on Mondays at ten o'clock in the morning with a critique of the previous week's work. The class assembled in the studio

LEFT: Fig. 3. William Merritt Chase demonstrating technique to students at Shinnecock Hills, late 1890s. Marshall County Historical Society, Holly Springs, Mississippi, Kate Freeman Clark Collection

RIGHT: Fig. 4. Chase's students painting at Shinnecock Hills, 1890s. Photo courtesy The Morris Studio, Southampton

building at Art Village and one by one the students' paintings were placed on a large revolving easel. As Chase criticized the work on one side of the easel the work of another student was placed on the other side, and the easel was turned around as needed. On Tuesdays Chase provided instruction in the field as his students painted from nature, which could require "a good deal of walking up hill and down hill, through brushes and brambles before his round of inspection was finished."[8] During the remainder of the week students were left to paint on their own and to prepare for the next Monday's critique—while Chase devoted himself to his own art.

Chase's Impressionism and the Shinnecock Landscapes

Most of Chase's paintings at Shinnecock were landscapes. Teaching outdoor painting, after all, was the reason he came to Shinnecock, and its gently rolling, delicately colored land, unobstructed views of blue water, and ever-changing cloud-filled sky made Shinnecock a wonderfully paintable place.

Before he came to Shinnecock Chase had only occasionally been interested in landscape as a subject, and he was not fitted by the dark palette of his Munich style—a studio style derived from traditions of art—to paint the high-key color and bright light that he captured with such extraordinary authority and sensitivity in his Shinnecock landscapes.

Chase became a committed landscape painter, it seems, not because of the influence of other landscape painting so much as from imperatives of modernism that he began to feel and act upon with increasing urgency in the 1880s and that by the end of the decade produced a wholesale revision of his art. If that process can be traced to a single beginning, it may have been an observation by the Belgian painter Alfred Stevens that, by Chase's own admission, had an enlightening effect upon him. Chase called on Stevens in Paris in the summer of 1881. Stevens told Chase that he admired Chase's portrait of Frank Duveneck, *The Smoker*, which received an honorable mention in the Salon exhibition that year (fig. 5), but he also criticized its deliberate imitation of earlier art. "Don't try to make your pictures look as if they had been done by the old masters," Stevens said, and Chase "saw the truth of his remark," for, Chase continued, "modern conditions and trends of thought demand modern art for their expression."[9] By the 1880s, modern art consisted chiefly, in general understanding, of two things:

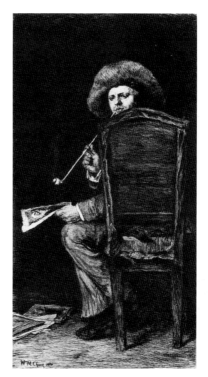

Fig. 5. William Unger, after William Merritt Chase, *Frank Duveneck*, etching, 1875. Private collection

contemporary subjects (such as, most especially, landscape) and open-air painting ("the open air," Mallarmé wrote in 1876, "influences all modern artistic thought"[10]). And it was precisely those things that entered Chase's art conspicuously and with transformative effect in the 1880s, particularly in the splendid series of paintings of Central Park in New York and Prospect Park in Brooklyn that he began making in 1886 (figs. 6, 7), paintings of distinctly modern urban subjects, filled with crisp and vibrant natural light and fresh natural color. As Chase's landscapes developed during the 1880s, so did his knowledge and appreciation of impressionism. Chase said then, "Impressionism, with the high keyed picture gave us some things that have come to stay, light, air, space—of which the old painters knew less."[11]

Just at this time other American artists experienced the direct influence of French impressionism: in 1887, Theodore Robinson, Willard Metcalf, John Breck, and Theodore Wendel first went to Giverny, Monet's home, and at about that time, too, Childe Hassam encountered impressionism in Paris. By about 1890, impressionist style was firmly established in America as the style of choice of advanced artists, and was widely represented in annual exhibitions, and frequently discussed in criticism.

There is no doubt, from what he said and how he painted, that Chase knew of the manner and method of French impressionism. And there is no doubt, either, that Chase's landscape style by the late 1880s and after can

LEFT: Fig. 6. William Merritt Chase, *The Lilliputian Boat Lake, Central Park*, c. 1890. Private collection

RIGHT: Fig. 7. William Merritt Chase, *Prospect Park, Brooklyn*, about 1887. The Parrish Art Museum, Southampton, Littlejohn Collection. Photo David Preston

be comfortably classified as impressionist. At the same time, Chase was not an orthodox impressionist: he did not, as other American impressionists did, base his style directly upon impressionist prototypes or derive it from actual contact with an impressionist artist. The names he invoked most often were not those of the impressionists, but Sargent, Whistler, and Velázquez; and the members of the impressionist circle he admired and whose work he owned—such as Manet, Morisot, De Nittis, Eva Gonzales, Degas, and Cassatt—were chiefly figure painters, not landscapists like Monet, Pissarro, or Sisley. Nor did Chase, as did others with varying degrees of closeness and consistency, obey what were by about 1890 clearly understood to be the systems and conventions of impressionist practice— formulas of coloration and handling of pigment that were, Chase felt, "more scientific than artistic."[12]

He never fully assimilated every aspect of impressionism. As one of his students observed, "[Chase] held out to the end that no one saw bright color in shadows."[13] And Charles De Kay said in 1891 of Chase's reservations about impressionism, "He is in annual danger of being classed by the young impatient impressionists among the old fogies, because he does not see things in gamboge [yellow] and purple."[14]

In 1890 another critic called Chase's an "American style," describing it as ". . . a composite blending indistinguishably the influences of old and new schools of painting."[15] This "composite blending" of old and new in Chase's work produced a paradoxical synthesis: the art of the old master Velázquez and the high-key palette of modern impressionism. He developed this synthesis in the landscapes he produced throughout the 1880s, and it reached its apogee in the Shinnecock landscapes of the 1890s.

Chase repeatedly admonished his students to avoid, as he himself did as a matter of principle, "recipes" of any kind, including those of impressionism.[16] A student at Shinnecock who did not avoid them was treated to a specimen of Chase's scornful wit:

> One summer when a hectic wave of impressionism was agitating the students' colony, several canvases were brought into the Shinnecock class showing lurid patches of yellow and blue. When Chase saw them he . . . began to hem and hum, tug at the string of his glasses, tap his stick upon the floor, and twist his moustache. Finally, with a slight frown, he turned upon the perpetrator—it was seldom necessary for him to ask his or her name. "And it was as yellow as that?" he asked.
> "Oh, yes, Mr. Chase. Really it was. The sun was right on it, you know, and it

was very yellow." The pupil babbled on, imagining that she was being very convincing.

"Hm," was Chase's reply, after another glance. "And September not yet here! Give the goldenrod a chance, madam. Give the goldenrod a chance."[17]

In 1891, before his first summer of teaching at Shinnecock, Chase said ". . . I have no fixed field or subjects. I think it is a mistake for an artist to confine himself to any one class of work. . . . I have tried most things."[18]

Chase, like the impressionists, did believe in painting "on the spot" and "right under the sky," with "all the light I can get," and he spoke repeatedly of capturing impressions, by which he meant fleeting sensations and transitory effects (his daughter, knowing his interest in them, once called to him, "Papa, come quickly; here is a cloud passing for you!"[19]). The Shinnecock landscapes, particularly, are redolent of nature seen directly, in full light, charged with movement. They are not products of pure seeing and impromptu observation only, however, but of pictorial decisions, whether studied or intuitive, that are deliberations of taste and sensibility. The location of the horizon (compare figs. 8, 9, 10), placement of figures, foliage, clouds, and accents of color (pls. 1, 3, 7, 8, 12), movement of line and internal design (pls. 11, 12, 15, 16), even picture shape (compare figs. 10, 11) are all matters to which Chase gave scrupulous care and consideration. And all are matters at least as instrumental in the paintings' success as their convincing description of fugitive impressions.

LEFT: Fig. 8. William Merritt Chase, *The Fairy Tale*, 1892. Collection of Mr. and Mrs. Raymond J. Horowitz

RIGHT: Fig. 9. William Merritt Chase, *Untitled (Shinnecock Landscape)*, about 1892. The Parrish Art Museum, Southampton

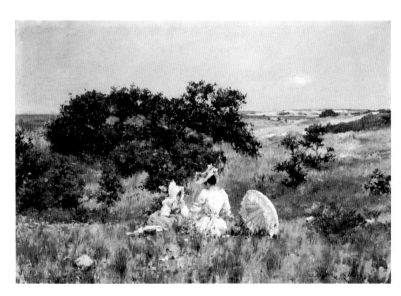

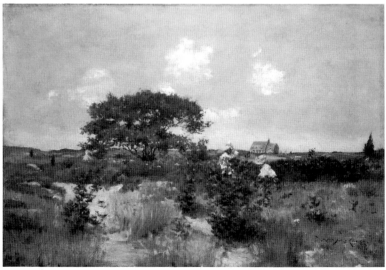

Chase was resistant to formula and pictorial dogma and open to any usable artistic source or resource; "Take the best from everything," he told his students, "Try all ways."[20] And, his impressionist style was a deduction from "modern conditions and trends of thought"—more than a borrowing of a currently fashionable language of form at the same time that it was infused with his unceasing admiration for the old masters. These factors combine to make his landscapes, and particularly his Shinnecock landscapes, some of the freshest, most original landscapes made in America to which the term impressionist can meaningfully be assigned.

The Shinnecock Landscapes

"[Chase] went to nature, stood before nature, and painted it as his eyes beheld it," said Rockwell Kent, who had been a student at the Shinnecock art school.[21] The landscapes confirm Kent's observation of Chase's approach to painting Shinnecock Hills. They are a direct visual record of the place as Chase encountered it during the 1890s. *Untitled (Shinnecock Landscape)*, of about 1892 (fig. 9), provides an understanding of Chase's use of the elements of space, light, and atmosphere in the Shinnecock paintings. In an open expanse unencumbered by trees or dense vegetation, three of the artist's children play in the foreground. The Chase house, further enhancing

LEFT: Fig. 10. William Merritt Chase, *Swollen Stream at Shinnecock*, about 1895. Private collection

RIGHT: Fig. 11. William Merritt Chase, *Gathering Autumn Flowers*, 1894 or 1895. From the Collection of Mr. and Mrs. Paul Mellon, Upperville, Virginia

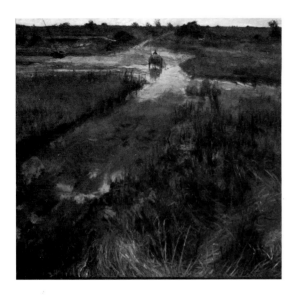

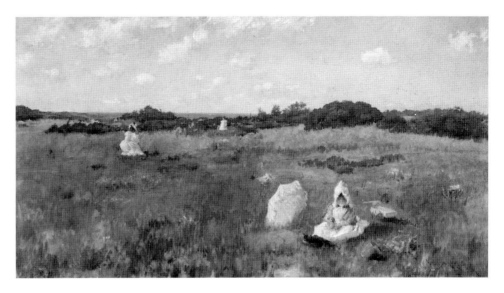

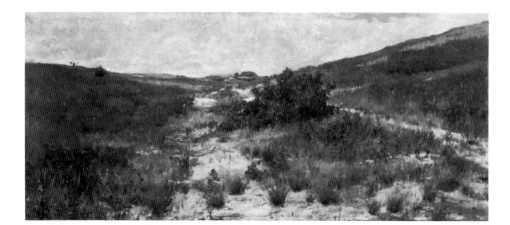

Fig. 12. William Merritt Chase, *Shinnecock Hills*, about 1892. Georgia Museum of Art, The University of Georgia, Athens, Eva Underhill Holbrook Memorial Collection of American Art, Gift of Alfred H. Holbrook, 1945

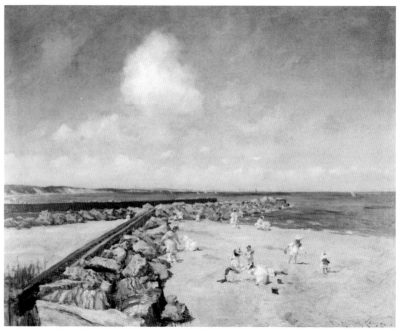

the sense of domesticity, is visible in the distance and establishes the artist as an integral part of the landscape, not a passive observer of it.

The viewer is given access to this scene at the same spot in the foreground in which Chase positioned himself when painting the picture, indicated by the subtle diagonal path that cuts through the grayish vegetation just to the left of center. Chase combined the artist's and the viewer's points of observation with a receding diagonal element in many of these paintings (figs. 12, 13, 14). This approach establishes the impression of a

LEFT: Fig. 13. William Merritt Chase, *Shinnecock Hills*, about 1895. Lent by National Museum of American Art, Smithsonian Institution, Washington, Gift of William T. Evans

RIGHT: Fig. 14. William Merritt Chase, *Morning at the Breakwater, Shinnecock*, about 1897. Terra Museum of American Art, Chicago; Daniel J. Terra Collection

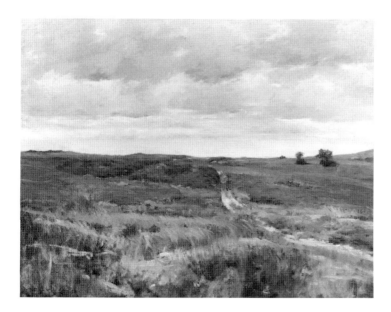

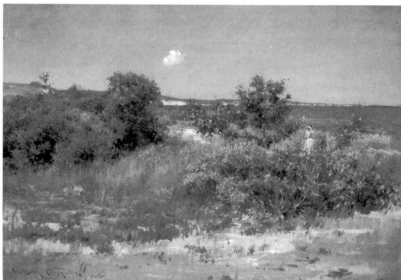

landscape open and available to the viewer, so benign that children play comfortably in the foreground.

In all of the Shinnecock landscapes the foreground is often the most painterly area, for the handling becomes tighter and more controlled in the distance (figs. 10, 15, 16). Chase told his students, "Do not put too much of the same handling in the foreground and middle distance. Break the surface of your shades. They will appear more natural."[22]

And in all of these landscapes the foreground is a rectangular plane that fills the bottom half of the composition and is terminated by the high horizon line of either ocean or dune. In an earlier interior scene, *Hide and Seek*, 1888 (fig. 17), Chase anticipated this compositional format. It is divided horizontally where floor meets wall in the same manner as land and water meet at the horizon in the landscapes. This line divides the composition almost in half, creating the same flat, upward-slanting plane that appears in the foregrounds of the later Shinnecock pictures.[23] Another formal similarity between this early interior and the landscapes is the asymmetrical distribution of compositional elements.

These compositional characteristics are, of course, borrowed from Japanese prints. Chase was certainly familiar with Japanese art, and a Japanese presence at Shinnecock is particularly strong. Chase dressed his models in kimonos (fig. 18), his children looked at Japanese prints (pl. 18), he had Japanese artifacts in his studio, took Japanese umbrellas to the

LEFT: Fig. 15. William Merritt Chase, *Over the Hills and Far Away*, about 1897. Henry Art Gallery, University of Washington, Seattle, Horace G. Henry Collection

RIGHT: Fig. 16. William Merritt Chase, *Shinnecock Hills, Peconic Bay*, about 1892. Jamee and Marshall Field

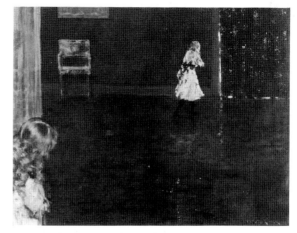

Fig. 17. William Merritt Chase, *Hide and Seek*, 1888. The Phillips Collection, Washington, D.C.

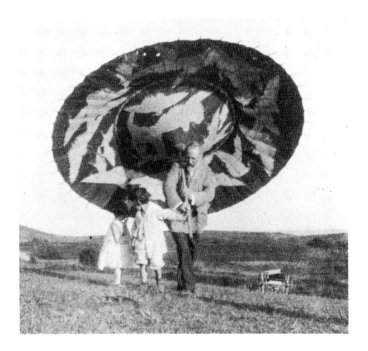

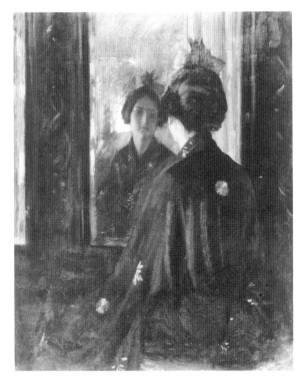

beach (fig. 19), and, when a child was born, he proclaimed its birth "in Japanese fashion, with a fish floating from the housetop."[24]

One of the things that Japanese art taught Chase was the importance of the picture edge and the positive formal consequences of pictorial limits and shape. And as with other issues that interested him, Chase made his students particularly aware of it. "It is never well to keep your work too much inside the frame," he said. "Carry it well out to the edge."[25] "Hold up a card with a square hole in it," he advised, "and put what you see through the opening on your canvas. . . . Let the edges of your picture lose themselves."[26]

The color and brushwork in *Untitled (Shinnecock Landscape)* remain consistent in other and later Shinnecock landscapes. The picture represents Chase's impressionist manner, a bright, high-key palette producing effects of brilliant sunlight. Some paintings are punctuated with points of color much warmer in hue than the surrounding area. This is evident in *At the Seaside*, about 1892 (pl. 2), in which concentrated areas of warm color in the red bonnet worn by the little girl, the pillow on which the woman reclines, and the pail and large Japanese umbrella visually push forward to balance the cooler, recessive hues of the composition. Often, this color accent is limited to only one small area, usually reserved for the cap or stockings of Chase's

LEFT: Fig. 19. William Merritt Chase with children under a parasol near the beach. The Parrish Art Museum, Southampton, William Merritt Chase Archives, Gift of Jackson Chase Storm, 1983

RIGHT: Fig. 18. William Merritt Chase, *The Mirror*, about 1900. Cincinnati Art Museum, Museum Purchase

oldest daughter. Such a recurrent feature of the Shinnecock paintings became known as "his red note."[27]

Much of these landscapes is sky. "Shinnecock . . . juts into the Atlantic Ocean and basks like Holland under an everchanging sky,"[28] wrote a contemporary. And a student at the school said, "The horizon is low-toned and warm, deepening in blue and growing colder as it rolls towards the zenith. The cumuli are magnificent, billowing and floating and changing so that paint and brush have a merry race to catch up with their manifold variations of form."[29] Chase was fascinated with the movement of clouds over Shinnecock. "Some days he spent hours at his window simply painting the changing clouds, veritable sky studies,"[30] reported Katharine Roof, Chase's early biographer. Much of his advice to his students concerned the painting of skies. "Try to paint the sky as if we could see through it," Chase told them, "and not as if it were a flat surface, or so hard that you could crack nuts against it." "Keep your sky open, and when painting a tree, make it look as though birds could fly through it." And in a rare direct reference to impressionism, Chase said, "The streaked appearance we see in the work of the impressionists is to convey the idea that the air vibrates, and that we can see through it like a screen; but most of them overdo it." [31]

Most of the pictures represent Shinnecock Hills under the bright sun and clear sky of high summer, but some represent a later season and different climatic conditions. In *Idle Hours*, about 1894 (pl. 6), a dark mass of gray clouds signals the approach of an impending storm. *Shinnecock Hills*, about 1892 (pl. 5), and *Over the Hills and Far Away* both depict overcast skies. *Swollen Stream at Shinnecock* is a soggy landscape after a sudden rainstorm. *Hunter with a Pointer in a Long Island Landscape*, about 1897 (pl. 15), records Shinnecock Hills in the brown and golden tones of autumn.

Chase signed his paintings regularly, but he almost never dated them. Their chronology, therefore, is uncertain. Some of the Shinnecock paintings can be dated through contemporary literary sources. In an article published in June 1893, John Gilmer Speed discussed Chase's life and art at Shinnecock during the previous summer. He reproduced five Shinnecock landscapes, including *Shinnecock Hills, Peconic Bay* (pl. 3), *The Fairy Tale* (pl. 1, fig. 8), and *Shinnecock Hills* (pl. 5, fig. 12), thus permitting one to date them all no later than 1892.[32] There is reason, too, from contemporary references and exhibitions, to think that both *Idle Hours* (pl. 6) and *Gathering Autumn Flowers* were painted in 1894 or 1895. And *Morning at the Breakwater, Shinnecock* (pl. 16, fig. 14) can be dated no earlier than 1897, for the

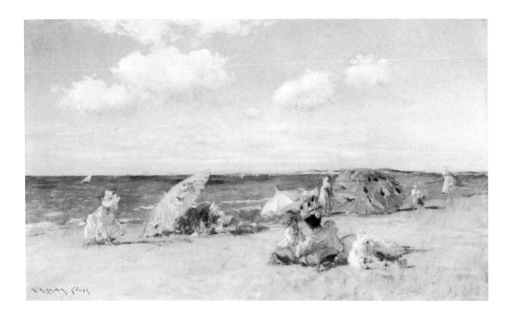

Fig. 20. William Merritt Chase, *At the Seaside*, about 1892. Lent by The Metropolitan Museum of Art, New York; Bequest of Miss Adelaide Milton de Groot, 1967

breakwater and canal represented in it were not completed until that year. Unfortunately, many of the Shinnecock landscapes remain insecurely dated, making the discussion of their development difficult. But, after all, development in the usual sense may not be an issue in them. There is, for instance, a case like *At the Seaside* (pl. 2, fig. 20) of about 1892, which is more different in style from a painting of the same period such as *The Fairy Tale* (pl. 1, fig. 8) than *The Fairy Tale* is from *Morning at the Breakwater, Shinnecock* of about five years later. Perhaps, as Charles Eldredge has suggested, instead of a linear development there were certain subjects and moods to which Chase returned time and again during his career.[33] Or perhaps Chase resisted falling into a conventional pattern of development from the same principle of openness that caused him to resist all other formulas and categories of style. In any event, stylistic analysis does not seem to reveal any discernible development in the Shinnecock landscapes.

Neither majestic nor sublime, these paintings embody the gentle quality of Shinnecock Hills and represent Chase at his best as an impressionist and as a landscape painter. Their appeal in both Chase's time and ours is in the manner they portray the warm and languid quality of a sunny afternoon and the companionship of family members. Chase's yearly retreat to Shinnecock Hills, painting over and over the landscape he encountered there, demonstrates his desire to establish the perfect balance of space, light, and atmosphere in his quest for the harmony in nature.

ATKINSON 28

Notes

1. John Gilmer Speed, "The Passing of the Shinnecocks," *Harper's Weekly* 36 (31 December 1892), 1258.

2. *Out on Long Island* (New York[?], 1890), 31–32.

3. Rosina H. Emmet, "The Shinnecock Hills Art School," *The Art Interchange* 31 (October 1893), 89.

4. John Gilmer Speed, "An Artist's Summer Vacation," *Harper's New Monthly Magazine* 87 (June 1893), 8.

5. "A School in the Sands," *Brooklyn Daily Eagle* (14 October 1894).

6. A. R. Ives, "Suburban Sketching Grounds. 1. Talks with Mr. William M. Chase, Mr. Edward Moran, Mr. William Sartain and Mr. Leonard Ochtman," *Art Amateur* 25 (September 1891), 80.

7. "School in the Sands" 1894.

8. "Summer Art at Shinnecock," *New York Herald* (2 August 1891).

9. "The Import of Art. By William M. Chase. An Interview with Walter Pach," *The Outlook* 95 (25 June 1910), 442.

10. Stéphane Mallarmé, "The Impressionists and Edouard Manet," *The Art Monthly Review* (September 1876), reprinted in Penny Florence, *Mallarmé, Manet, and Redon: Visual and Aural Signs and the Generation of Meaning* (Cambridge, England, and New York, 1986), 16.

11. Marietta Minnigerode Andrews, *Memoirs of a Poor Relation* (New York, 1927), 394.

12. Quoted in Ronald G. Pisano, *A Leading Spirit in American Art: William Merritt Chase 1849–1914* (Seattle, 1983), 154.

13. David Milgrome, "The Art of William Merritt Chase" (Ph.D. diss., University of Pittsburgh, 1969), 48.

14. Charles De Kay, "Mr. Chase and Central Park," *Harper's Weekly* 35 (2 May 1891), 327.

15. William Howe Downes, "William Merritt Chase, A Typical American Artist," *International Studio* 39 (December 1909), XXIX–XXXVI.

16. Quoted in Pisano 1983, 154.

17. Katharine Metcalf Roof, *The Life and Art of William Merritt Chase* (New York, 1917), 180–181.

18. Ishmael, "Through the New York Studios—IV. William Merritt Chase," *The Illustrated American* 5 (14 February 1891), 618–619.

19. Quoted in Pisano 1983, 154.

20. "Notes from Talks by William M. Chase," *The American Magazine of Art* 8 (September 1917), 434, 438.

21. Rockwell Kent, *It's Me O Lord* (New York, 1955), 76.

22. Charles C. Eldredge, "William Merritt Chase and the Shinnecock Landscape," *The Register of the University of Kansas Museum of Art* 5 (1976), 17.

23. Eldredge 1976, 17.

24. Roof 1917, 185.

25. Andrews 1927, 399.

26. Lillian Baynes, "Summer School at Shinnecock Hills," *The Art Amateur* 34 (October 1894), 91–92.

27. Roof 1917, 176.

28. Ernest Knaufft, "An American Painter—William M. Chase," *International Studio* 12 (January 1901), 156.

29. Andrews 1927, 288.

30. Roof 1917, 176.

31. Baynes 1894, 91.

32. Speed 1893.

33. Eldredge 1976, 21.

Impressionism and Expression in the Shinnecock Landscapes: A Note

NICOLAI CIKOVSKY, JR.

CHASE'S IMPRESSIONISM FIRST APPEARS with consistency and conviction in his Prospect Park and Central Park paintings of the late 1880s. The Shinnecock landscapes that followed them in the early 1890s are in two respects different. They are, first, more fully chromatic, their brilliancy obtained less by the sharp contrasts of light and dark that Chase employed (with wonderful effect) in his park paintings, than by, in the Shinnecock landscapes, the hues and key of color itself. Second, the park scenes depict public places and public activities; the Shinnecock landscapes, despite their spaciousness, are more essentially private. Most of them are located in the area surrounding Chase's house at Shinnecock, and depict his wife and children enjoying the pastimes of summer, gathering flowers in the fields and shells on the beach, reading, strolling, and sunning themselves (pls. 1–4, 6–9, 12, 14, 16).

Chase produced landscapes (and other paintings, too) with particular enthusiasm during his first years at Shinnecock—at a rate of two pictures a week in 1892, one writer said[1]—inspired, surely, by the novelty of the place and the challenge of its unconventional landscape ("the whole of Shinnecock can hardly boast of one tree"[2]), by a sense of domestic well-being reflected in the perfect, untroubled tranquility of his imagery, and, in the summer of 1892 when he painted some of the loveliest landscapes, simply by unusually fine, sunny weather.[3] We can say with a certain amount of confidence what some of those paintings were (pls. 1, 2, 3, 5). But that is an unusual circumstance, because the Shinnecock landscapes,

OPPOSITE PAGE: Detail, *Shinnecock Hills*, about 1895. Private collection

31

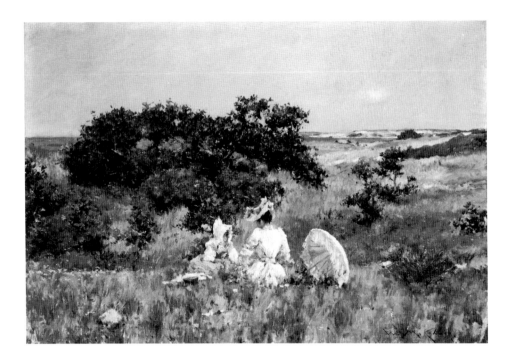

like all of Chase's work, cannot be accurately dated. For that reason, of course, it is difficult and imprudent, as Scott Atkinson has justly observed in the preceding essay, to speak with assurance of their chronology. What is more, as he has shown, on the basis of what we do know of their dating they do not undergo an undeviatingly linear stylistic development. A work such as *The Fairy Tale* of 1892 (fig. 1), unquestionably among the earliest of the Shinnecock landscapes, is in certain prominent features of style—principally those of coloration and facture—very like those of *Morning at the Breakwater, Shinnecock* (fig. 2) that is surely at least five years later. Nevertheless, as these two paintings also show, there can in other respects be significant and suggestive differences between the Shinnecock landscapes in pictorial construction and its expressive effect. For they are not, as a group, completely uniform in style or in meaning. However difficult it is to match differences in style and changes in date with satisfactory precision, and whatever caution that difficulty imposes, stylistic differences, and the possibility that those differences correspond in some degree to developments in time, are real enough that they ought not go unnoted in the discussion of Chase's Shinnecock landscapes.

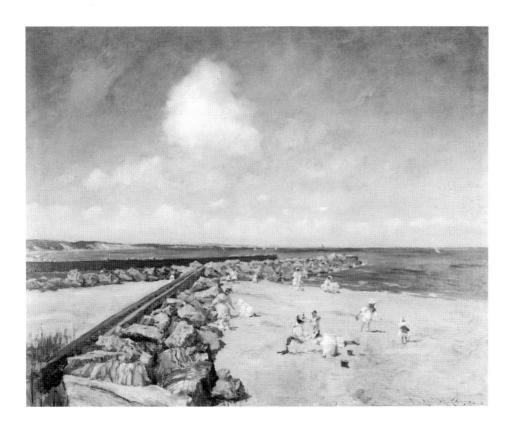

Fig. 2. William Merritt Chase, *Morning at the Breakwater, Shinnecock*, about 1897. Terra Museum of American Art, Chicago; Daniel J. Terra Collection

The earliest landscapes, on the whole, depict ordinary events of Chase's life at Shinnecock with uncomplicated descriptiveness, with a savor of sensation and a pure pleasure in seeing and what is seen. They are views, records of experience: "When I have found the spot I like, I set up my easel, and paint the picture on the spot,"[4] Chase said in 1891, of his painting procedure at about the time of the early Shinnecock landscapes. The emphasis is on what is directly seen, without the overt intervention of art: compositions, for example, are reticently symmetrical, picture shape inconspicuously standard (figs. 1, 3, 4). There is an inescapable feeling of innocence in the early Shinnecock landscapes that is a function of their serene and untroubled subjects—the harmony that Chase said he saw in nature[5]—but also, one might say, of the innocent simplicity of their making.

In time, that changed. The change begins to be evident in paintings very roughly datable to the middle 1890s, in which aesthetic and formal considerations play a distinctly greater and more visible part. Chase's

power of seeing and recording was no less acute, but accompanying it there was an equal attentiveness to art and artifice, to refinements of composition (the sophisticated asymmetrical balance of pls. 7 and 8), to design (the carefully plotted and artfully paced accents of figures and colors in pls. 7, 8, and 9 that articulate pictorial space), and to picture shape (the self-assertively oblong rectangle of pl. 8, for example).

In other landscapes thought to be of the middle and late 1890s the change is even greater (figs. 2, 5; pls. 11, 12, 15, 16). There is in them a rigor of design, a vigor of linear movement, and a largeness of shape stylistically different in degree, and also in kind, from what can be found in the earliest landscapes. And in the angular tensions and acuities in the direction and intersection of line, internally with itself and with the framing edges, and the sudden, deep thrusts into space, there is an expressiveness that gives them a different meaning as well. In his early Shinnecock landscapes, Chase said, he tried to reproduce on canvas the harmony of nature. But in later landscapes there is positive disharmony in the thrusts and tensions that are their most telling visual effect—all the more telling because they occur in paintings significantly larger in size than the earlier ones had been (pls. 11, 12, 16).

There are other signs of change. In the later paintings, Chase did not depict his family as single-mindedly as he once did, or in the same cohesive, intimate groupings. Later ones are more restrained in coloration, emptier

LEFT: Fig. 3. William Merritt Chase, *Untitled (Shinnecock Landscape)*, about 1892. The Parrish Art Museum, Southampton

RIGHT: Fig. 4. William Merritt Chase, *Shinnecock Hills, Peconic Bay*, about 1892. Jamee and Marshall Field

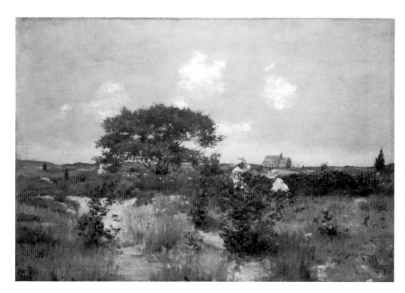

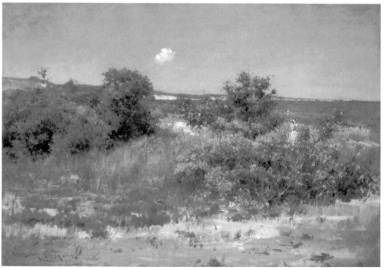

and sparer, and more responsive to nature's graver moods and sadder moments, to cloudy weather or the cooler, subdued colors of autumn at Shinnecock. The landscape there had not changed. But Chase's perception of it did. The later landscapes are as beautifully subtle in color and as true to particular experiences of nature as the early ones had been. But they are nevertheless very different. To the degree that the serene subjects and uncomplicated form of the earlier landscapes can be said to reflect Chase's contentment with his life and the composure of his mind, then the moods of subject and the modes of form of the later landscapes may in like degree be the reflection of something very different. In 1895 and 1896, it seems, Chase experienced a crisis of confidence and purpose that caused him seriously to examine and, as one writer put it, change "his whole method of life."[6] He gave up the Tenth Street Studio, auctioned its contents, and announced his intention to give up teaching and devote himself more wholly to his art. It was, perhaps, the pressure of the emotional causes, or consequences, of that change that, by the middle 1890s, transformed his landscape style from what had been largely an instrument of seeing into one that was

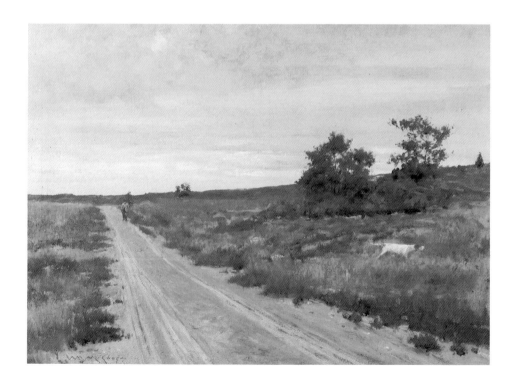

Fig. 5. William Merritt Chase, *Hunter with a Pointer in a Long Island Landscape*, about 1897. The Shearson Lehman Brothers Collection

at least as much an instrument of feeling, from one devoted largely to optical description into a vehicle of compelling expressive address.

In March of 1891, a few months before Chase's first summer at Shinnecock, a sympathetic critic summarized Chase's artistic evolution on the occasion of the exhibition and sale at auction of a large group of his paintings and pastels.

> If the belief, too common a few years ago, that Mr. Chase is merely a clever workman with the brush is still held by any belated spirits, a survey of the present collection should remove it. Truly, few cleverer technicians are alive to-day; but to qualities of hand he adds . . . rare qualities of eye; his coloring is now of the most delightful delicacy and now of the most audacious vigor. . . .[7]

He described the development in Chase's art from the technical display of his early, Munich-inspired paintings to his optical and chromatic ones, a change, he implied, not merely in its outward aspect of style, but in its greater substance and authority. If the same critic had written again on a similar occasion a year or two later of the early Shinnecock paintings, he would have been impressed by the even greater delicacy and vigor of their color and by their still rarer, their keener and subtler, qualities of eye. And if he had written two or three years after that he should have noticed something else, and something more—noticed that Chase, who in 1895 attempted to change his life, also changed his art, empowering it to contain and express conditions of feeling and kinds of meaning that earlier it had been neither concerned nor equipped to do, and endowing it with a dimension of seriousness and substance not expected of a mere "clever workman with the brush."

Notes

1. John Gilmer Speed, "An Artist's Summer Vacation," *Harper's New Monthly Magazine* 87 (June 1893), 7.

2. Rosina H. Emmet, "The Shinnecock Hills Art School," *The Art Interchange* 3 (October 1893), 89.

3. ". . . the days in July down on Long Island last summer were so bright and pleasant that it was impossible to keep inside of the house for long at a time. . . ." Speed 1893, 6.

4. A. R. Ives, "Suburban Sketching Grounds. 1. Talks with Mr. William M. Chase, Mr. Edward Moran, Mr. William Sartain and Mr. Leonard Ochtman," *Art Amateur* 25 (September 1891), 80.

5. Ives 1891, 80.

6. Philip Poindexter, "A Foremost American Painter," *Leslie's Weekly* 80 (16 May 1895), 319.

7. "Some Questions of Art. Pictures by Mr. William M. Chase," *New York Sun* (1 March 1891).

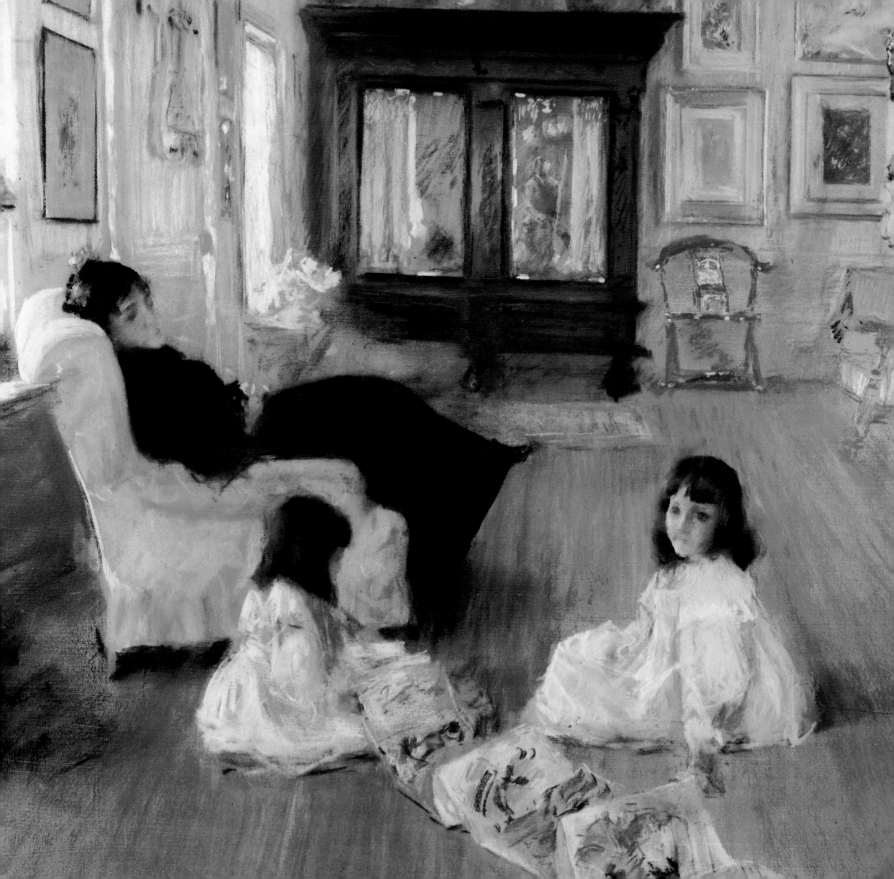

Interiors and Interiority

NICOLAI CIKOVSKY, JR.

CHASE'S SUMMERS AT SHINNECOCK were not vacations. He taught regularly each week every summer that he was there, from 1891 to 1902. And he painted with a sustained energy and authority, with a thoughtfulness, sincerity, and concentrated feeling, greater than at any time of his life.

The landscapes Chase painted at Shinnecock are as a group the best paintings he ever made. They belong, too, among the highest attainments of American impressionism (perhaps because they have so little directly to do with impressionist formulas of style) and they are the paintings by which, quite singlehandedly, Chase made Shinnecock one of the great sites of impressionist painting. But his interiors, the paintings in oil and pastel of his house and studio at Shinnecock, are every bit as beautiful as his landscapes, and in certain ways deeper and more complex as art, more layered in meaning, richer in reference, and more revealing—more reflexive and reflective—of Chase himself.

Chase in the 1890s

By the 1890s, when Chase summered at Shinnecock, his artistic enterprise, earlier almost wholly public, became increasingly personal and private. During the decade or so that followed his return to America in 1878 after six years of study in Europe, Chase campaigned tirelessly in the cause of art. The impeccable elegance of his outward appearance—his careful dress, precisely trimmed beard, top hat, spats, cane, boutonniere—proclaimed his belief in the nobility and special dignity of the artistic profession (fig. 1), just as the set-

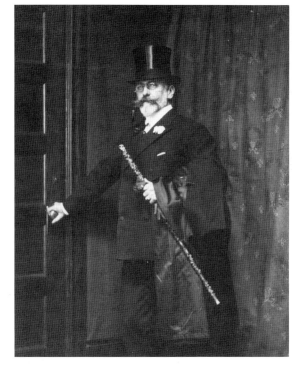

Fig. 1. *William M. Chase*, 1906. Akron Art Museum, Edwin C. Shaw Notebooks. Photo Archives of American Art

OPPOSITE PAGE: Detail, *Hall at Shinnecock*, 1892 or 1893. Terra Museum of American Art, Chicago; Daniel J. Terra Collection

39

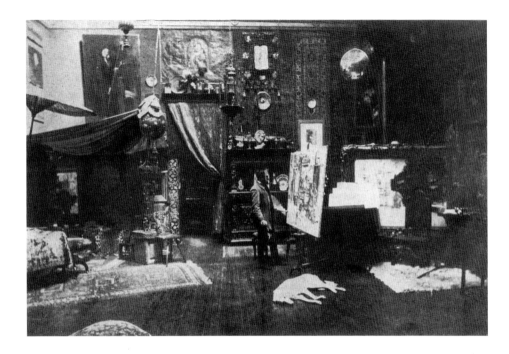

Fig. 2. *William M. Chase in His Studio*. From *The Commercial Advertiser* (10 February 1900)

ting he made for himself, the lavishly decorated studio in the Tenth Street Studio Building in New York (fig. 2)—"the finest studio in this city, if not in the whole country"[1]—was a shrine to Art and a visible manifesto of Chase's ruling belief that art was nourished by other art and was properly made only in its "atmosphere." For the guidance of his countrymen in these matters, Chase made himself the example, the public impersonation, of his ideal of art. He "carried the banner, and announced that art had come to town;"[2] his studio, which "thousands" knew,[3] was "one of the sights that artists and students, coming to New York, desire to see."[4] In his early years in New York, Chase was part performer, part polemicist, and part publicist, with the publicist's special gift for attracting the notice of the press.[5] But his professional life was more than a symbolic performance. He taught unceasingly—privately, and at the Art Students League, the Chase School, Brooklyn Art Association, and Pennsylvania Academy—and, as a founding member and, for more than ten years, president of the Society of American Artists, he was prominently identified and closely engaged with advanced art and artists and occupied a central position in the artistic politics of his time.

Chase married in 1886; children soon arrived, some by the time he came to Shinnecock, others while he was there (eight survived). This domestication made a profound change in Chase's life. That it had an equally profound ef-

The House and Studio at Shinnecock

Chase's house was on the outskirts of civilization at Shinnecock, significantly removed from more concentrated development along Shinnecock Bay and along the South Highway to the south and east, and on the southern edge of the unimproved land of the Shinnecock Land Company that stretched northward to Great Peconic Bay (fig. 5; pl. 4). Used earlier for grazing, the land around it was without trees and covered only with beach grasses and low bushes. In that empty landscape stood the house—"a frame and shingle structure in what is called the Colonial style"[11]—that was, it is usually said, designed for Chase by his friend, the architect Stanford White. It was designed by White; the rendering for it is in the McKim, Mead & White archives (fig. 6). However, the archives show it was not planned for Chase himself but for another resident of Shinnecock, Charles L. Atterbury. It may even have been planned for another site, for the rendering shows the house much closer to the water than it is on its present landlocked lot, and more, it seems, as it might be situated on Atterbury's property that fronted on Shinnecock Bay (fig. 5). It is not certain to what extent or in what way the house was changed internally for Chase (no plans for it survive), but the house as built is just as it appeared in the original architectural rendering.[12]

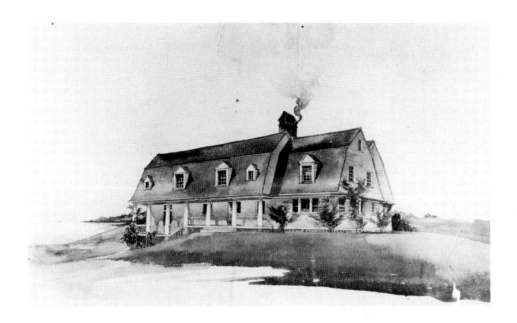

Fig. 6. Rendering of Chase's house at Shinnecock, about 1888. Columbia University, New York, Avery Architectural and Fine Arts Library, McKim, Mead & White Collection

OPPOSITE PAGE: Fig. 5. Detail, map showing Shinnecock Hills. *Atlas of Suffolk County, Long Island, New York* (Brooklyn, 1902), 1:6. Courtesy Library of Congress, Washington, Map Division

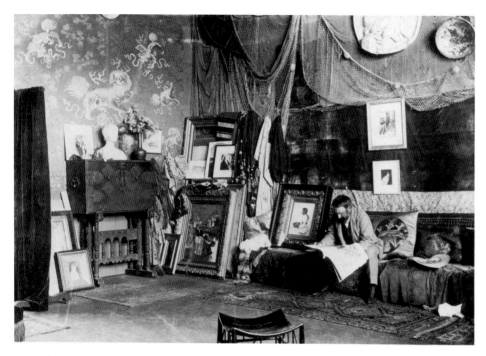

Fig. 7. Chase in his studio at Shinnecock, about 1892.
Photo courtesy Mrs. Wayne Morrell

The McKim, Mead & White archives show that the house was designed in 1888. But Chase spent his first summer at Shinnecock, 1891, at the inn that had been built there as part of its development[13] and did not occupy the "*new* and charming house"[14] until the summer of 1892.

As the house is now situated, Chase's studio was located in a tall square room at the west end (at the left of the McKim, Mead & White rendering). Its height is suitable for a studio, though, as the rendering shows, that was part of the original design and a function of the site, and cannot have been Chase's modification. On the whole, in view of the room's relative smallness, and the fact that Chase kept a bank of windows in the west wall covered with hangings (figs. 7, 8), it is difficult to believe, as one writer claimed, that the room was "specially planned for a studio."[15] What is more, the only significant architectural modification was probably the large window added in the north wall, an essential attribute of a studio but unnecessary in what was originally a private house. It was Chase's decorations, not ar-

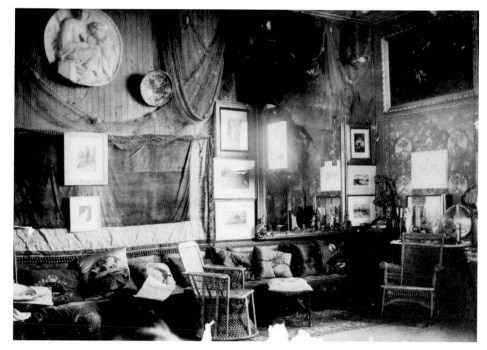

Fig. 8. Chase's studio at Shinnecock, west wall, about 1892.
Photo courtesy Mrs. Wayne Morrell

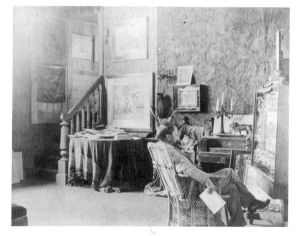

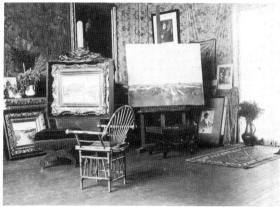

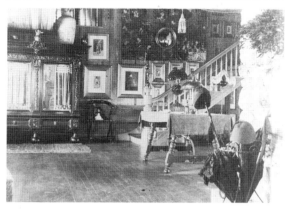

chitectural changes, that decisively transformed the room into a studio. He covered the walls with hangings, and filled the room with furniture, bric-a-brac, art objects, reproductions, and paintings, chiefly his own (figs. 7, 8, 9, 10), that gave him things to paint and the inspirational "atmosphere" in which to work.

The studio was reached by a short flight of stairs (fig. 9) descending from the large central hall of the house proper. That, too, Chase embellished with hangings, pictures, objects of art, and a large armoire with mirrored doors (fig. 11).

The archaeology of the Shinnecock house bears in several ways upon what Chase did there. It establishes where the Shinnecock interiors were painted, what they depicted, and how exactly they depicted it; it documents resources and influences that acted upon Chase; and it provides some evidence for the dating of Chase's Shinnecock paintings.

TOP: Fig. 9. Chase in his studio at Shinnecock, east wall. CENTER: Fig. 10. Chase's studio at Shinnecock. BOTTOM: Fig. 11. Hall of Chase's house at Shinnecock. All photos about 1892, courtesy Mrs. Wayne Morrell

The Paintings

One of the earliest of the Shinnecock interiors is *In the Studio* (fig. 12 and pl. 17), painted almost certainly in the summer of 1892. It is mentioned in a description of that summer's work,[16] and appears in a photograph of the studio (fig. 13), published in September 1892,[17] in which Chase is, or is pretending to be, at work on it (while in the background, at the right, as further evidence of its early date, is a portrait of his mother said to be the first painting he did in the Shinnecock studio[18]); a photograph showing *In the Studio* leaning against the studio wall (fig. 7) was probably made in 1892 also. *In the Studio* depicts Chase's most frequent model in the Shinnecock interiors, his wife, Alice Gerson Chase. She sits in the large rattan chair that appears in a photograph of the studio (fig. 9), in which are visible, too, the studio furnishings precisely as they are in the background of the painting.

The large pastel, *Hall at Shinnecock* (pl. 18), was also mentioned in the description of the summer's work of 1892.[19] One of the largest and most ambitious of the Shinnecock interiors, it depicts Mrs. Chase and two of the Chase children in the central hall, and Chase himself reflected in the mirror of the armoire. It was exhibited in 1894 at the Pennsylvania Academy of the Fine Arts, and published for the first time in 1895.[20]

The publication and exhibition of two other Shinnecock interiors in the spring of 1894 supply a terminal date for their execution (though given the time that could elapse between the execution of a work and its exhibition or publication, that is clearly not a reliable guide). One is a pastel, also called *In the Studio* (fig. 14 and pl. 19), in which Mrs. Chase is again the model. It depicts the east wall of the studio just to the left of the segment depicted in the other painting by the same name (the bit of gilt frame to the left of the earlier painting belongs to the painting seen behind Mrs. Chase at the right of the pastel), and includes the stairs from the hall of the house (fig. 9), and to their right, in the center of the composition, a large engraving (probably the one by Gustave Mercier) after Henri Regnault's *Automedon and the Horses of Achilles* (fig. 15). Although painted many years earlier, in 1868, and in a mode of academic style (it was Regnault's *envoi* from the French Academy in Rome) distant from Chase's own training and stylistic affiliations, and especially from his modernized style of the 1890s, *Automedon and the Horses of Achilles* was nevertheless timely when Chase included it as one of the most prominent objects in the decoration of his Shinnecock studio. For in 1890 the painting was acquired by subscription for the Museum

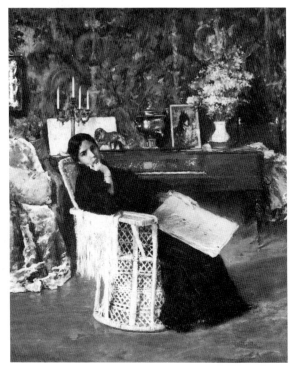

Fig. 12. William Merritt Chase, *In the Studio*, 1892. Mr. and Mrs. Arthur Altschul. Photo Nathan Robin

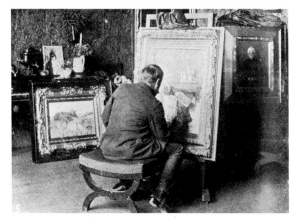

Fig. 13. Chase in his studio, 1892, from *Demorest's Family Magazine* 33 (April 1897), 308. Photo Library of Congress, Washington

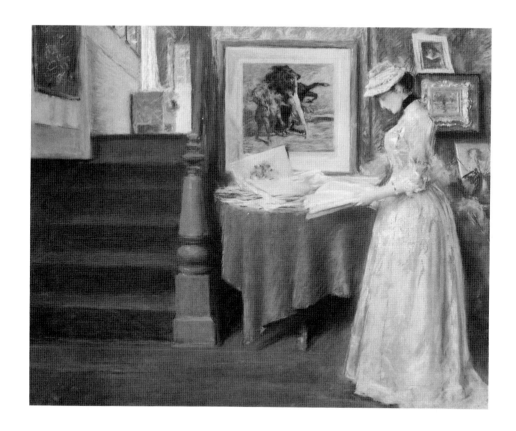

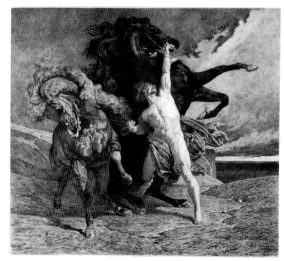

Fig. 15. Gustave Mercier, *Automedon and the Horses of Achilles*, engraving after the painting by Henri Regnault. Museum of Fine Arts, Boston, Samuel P. Avery and Special Print Funds

Fig. 14. William Merritt Chase, *In the Studio (Interior: Young Woman at a Table)*, 1892 or 1893. Hirshhorn Museum and Sculpture Garden, Smithsonian Institution, Washington. Gift of Joseph H. Hirshhorn, 1966

of Fine Arts in Boston as the result of an energetic campaign by the students of the Museum School.[21] It is perhaps not farfetched to think, therefore, that Chase regarded Regnault's *Automedon*, particularly in view of the prominent place he gave it in his studio, not as a relevant paradigm of style, but as an emblem of the challenge to authority and received opinion that had been a central motivation of artistic life.

Reflection or *Reflections* (it is given both ways) (fig. 16 and pl. 20) was also published in 1894 and was exhibited that spring at the Society of American Artists. It, too, depicts Mrs. Chase. Although seated in the same large rattan chair in which she was seated in *In the Studio* (fig. 12), she is located, not in the studio but in the hall (fig. 11), close to the large armoire in the mirrored doors of which she and the arched entrance to the dining room behind her (fig. 17) are reflected.

A Friendly Call (fig. 18 and pl. 21), inscribed in Chase's hand, "Copyright 1895" (the only Shinnecock interior actually dated), was exhibited at

the Society of American Artists exhibition in the spring of that year, where it received the Shaw Prize of fifteen hundred dollars. Mrs. Chase and a veiled visitor are seated on the banquette that ran along the west wall of the studio (figs. 7, 8), in front of a large mirror that reflects the wall depicted in the pastel, *In the Studio* (pl. 19). The chair at the right was a piece of studio furniture (fig. 10), and reappears in other Shinnecock interiors (fig. 33); the pillow in it appears also in *Idle Hours* (pl. 6).

Five of the Shinnecock interiors can be dated between 1892 and 1895, and probably in an even briefer period than that. (For example, *A Friendly Call* was reproduced in the spring of 1895.[22] But considering both the time it would take to make such an ambitious painting, and the season, that is too early for it to have been painted at Shinnecock that year. It is far more likely, therefore, that it was painted the year before. If so, it was copyrighted the year it was exhibited and illustrated, in 1895, not when it was painted.)

The largest number of the interiors were made in Chase's first two or three years at Shinnecock. They were painted, it seems, with a special intensity of interest and purpose. One writer described "four pictures made during two weeks" in the summer of 1892, adding "this rate was maintained during the whole vacation,"[23] and although the interiors vary

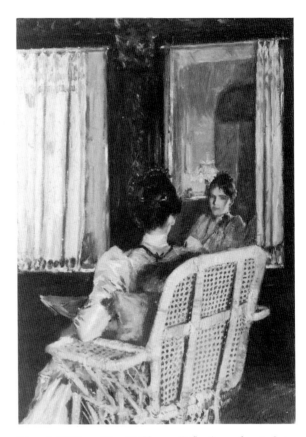

Fig. 16. William Merritt Chase, *Reflections*, about 1893. Collection of Mr. and Mrs. Raymond J. Horowitz

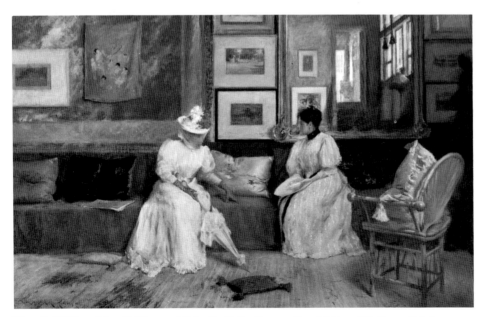

Fig. 18. William Merritt Chase, *A Friendly Call*, 1894 or 1895. National Gallery of Art, Washington, Chester Dale Collection

Fig. 17. Chase's dining room at Shinnecock, about 1892. Photo courtesy Mrs. Wayne Morrell

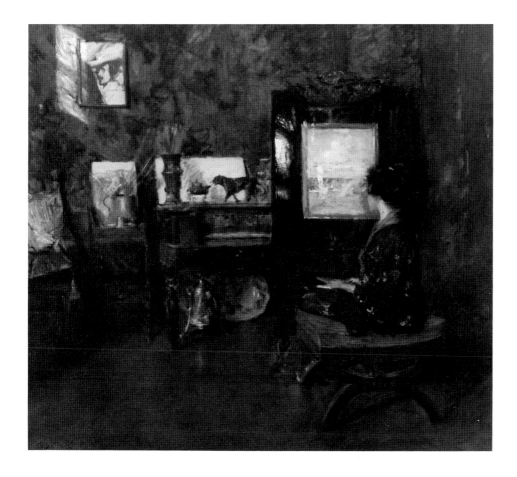

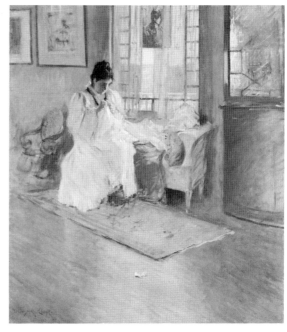

Fig. 19. William Merritt Chase, *For the Little One*, about 1896. Lent by The Metropolitan Museum of Art, New York; Amelia B. Lazarus Fund by exchange, 1917 (13.90)

Fig. 20. William Merritt Chase, *Alice in the Shinnecock Studio*, about 1901. The Parrish Art Museum, Southampton, Littlejohn Collection

greatly in size, medium, and site, a conception of seriality, a relationship of some cohesive, if not absolutely rigorous, system and sequence, seems to operate in them.

Other interiors, more singularly conceived and later in date, fall outside this group. *For the Little One* (fig. 19 and pl. 22)—Mrs. Chase sewing for (or in expectation of) a new child in the light of a north window in the hall—was exhibited in 1897 at the Society of American Artists. It was a spring exhibition, however, and the painting was probably done earlier. *Did You Speak to Me?* (pl. 23) was shown at the Society of American Artists and at the Third Annual Exhibition of the Carnegie Institute in 1898 and it, too, was very likely painted the year before. The sitter is most plausibly Chase's oldest daughter, Alice Dieudonnée, born in 1887. She is the sitter, too, in *Alice in the Shinnecock Studio* (fig. 20 and pl. 24), which is, perhaps, the

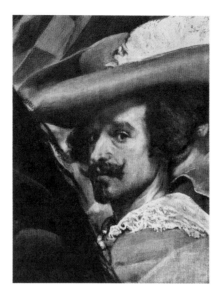 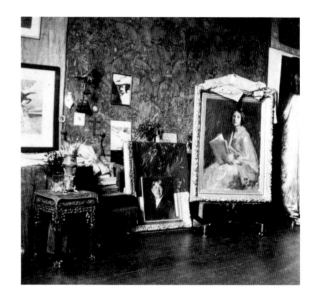

painting titled *In the Studio* that was exhibited in 1902 at the Society of American Artists. If so, it was painted during Chase's last summers at Shinnecock. She is seated on the same stool, in front of the same wall seen in *Did You Speak to Me?*, both of which are visible in photographs and paintings of the studio (figs. 9, 10). But in *Did You Speak to Me?* and *Alice in the Shinnecock Studio* the objects on and against the wall are different from those in the first series of Shinnecock studio interiors. Neither the chair on which the framed landscape rests nor the work hanging above it on the wall at the left in *Did You Speak to Me?* appear in early paintings or photographs of that part of the studio (compare fig. 9). In *Alice in the Shinnecock Studio* things have been more drastically rearranged. The candelabra is gone, replaced by a vase holding paint brushes, and a reproduction of a detail from Velázquez' *Surrender of Breda*, believed at the time to be Velázquez' self-portrait, appears on the wall as it did not earlier (figs. 21, 22).

Sources and Influences

Velázquez was the ruling artistic presence at Shinnecock. He was not, however, a discovery of the Shinnecock years. Chase had made a trip to Madrid in the summer of 1881 specially to study and copy Velázquez, and

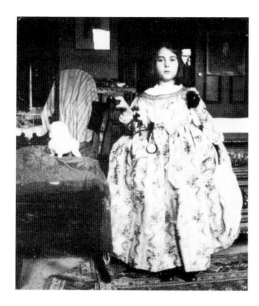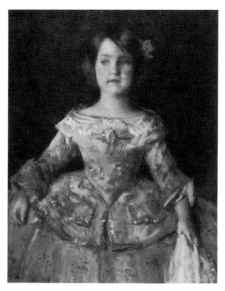

a number of paintings of the 1880s, like his famous portrait of Whistler, paid him the homage of undisguised imitation. But never before was Velázquez' influence as intense or pervasive as it was at Shinnecock. Chase hung his portrait like a pinup on one wall of his studio and had a detail from *Las Meninas* on another (figs. 22, 10); he dressed and painted his daughter Helen (whose middle name was Velasquez) as one of Velázquez' infantas (figs. 23, 24); and references to him, both open and oblique, recur in the Shinnecock interiors.

Velázquez was not Chase's private enthusiasm, of course, but one he shared with many of his contemporaries (like his friends Whistler and Thomas Eakins). They all took him as a model of style. But he was an equally important example for Chase in other ways. The diversity of his subject matter was the justification of Chase's own eclecticism: "It is gratifying to think," he said, "that the master I admire above all others had no specialty—that he was equally interested in portraits, landscapes, cattle, still life and everything else."[24] And Velázquez was, among earlier artists, the example of what Chase himself was trying to accomplish in the 1890s: "Of all the old masters he is the most modern,"[25] Chase said, for "with all his acquirement from the masters who had gone before him," he explained—describing in the process his own artistic derivation and intention—he "felt the need of choosing new forms and arrangements, new schemes of

LEFT: Fig. 23. Helen Velasquez Chase as an *infanta*. The Parrish Art Museum, Southampton, William Merritt Chase Archives, Gift of Mrs. A. Byrd McDowell, 1976

RIGHT: Fig. 24. William Merritt Chase, *My Little Daughter Helen as an Infanta*, 1899. Santa Barbara Museum of Art, Lent by Joel R. and Mary Ellen Strote

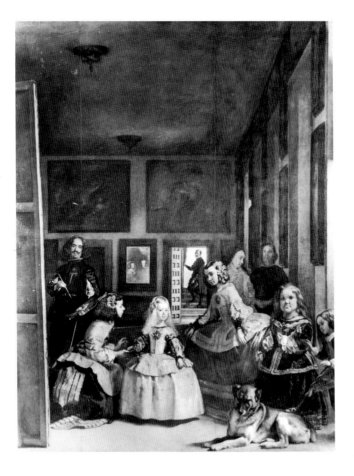

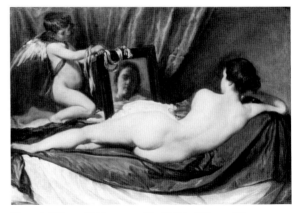

Fig. 26. Diego Velázquez, *The Toilet of Venus* (The "Rokeby Venus"), 1648. National Gallery, London

Fig. 25. Diego Velázquez, *Las Meninas*, 1656. © Museo del Prado, Madrid. All rights reserved

color and methods of painting, to fit the time and place he was called upon to depict."[26]

It was by the terms of that understanding of Velázquez, perhaps, that Chase recast Velázquez' greatest and most challenging painting, *Las Meninas* (fig. 25), into his most complex and ambitious images of modern life and manners, like *A Friendly Call* and *Hall at Shinnecock*, or conceived his wife in *Reflections* as a modernized, though chastened and truncated, version of the so-called "*Rokeby Venus*" (fig. 26).

On the same European trip in the summer of 1881 that Chase had his first important experience of Velázquez' art he received a piece of advice from a contemporary artist that had, by his own admission, a similarly great effect on him—one, indeed, that helped him understand the "sublime example" of Velázquez in modern terms.[27] During a week spent in Paris before returning to America Chase called on the Belgian painter Alfred

Stevens. Stevens expressed his admiration for Chase's (now lost) portrait of Frank Duveneck, *The Smoker* (fig. 27), exhibited that year at the Salon, but criticized its insistent debt to earlier art. " 'Chase, it is a good work, but don't try to make your pictures look as if they had been done by the old masters.' I saw the truth of his remark," Chase added; "modern conditions and trends of thought demand modern art for their expression."[28]

In the process of modernizing his art and correcting the "error," as he called it,[29] of imitating the old masters, Chase was guided not only by Stevens' exhortation but, more concretely, by his art, for Stevens was one of the most prominent and popular painters of modern life.[30] Chase himself owned a number of Stevens' paintings, and he surely knew others. The clearest evidence of that knowledge is found among the Shinnecock interiors. For instance, *The Mirror* (fig. 28)—Alice Dieudonnée in a Japanese kimono, reflected in the mirrored door of the armoire in the hall at Shinnecock[31]—is an unmistakable reprise of Stevens' *The Japanese Robe* of about 1872 (fig. 29), and it may also have played a role, though obviously a less direct one, in the conception of *Reflections*. It is an easy matter to account for the influence of *The Japanese Robe*: as a gift of Catharine Lorillard Wolfe to the Metropolitan Museum of Art in 1887, Chase would have had ready access

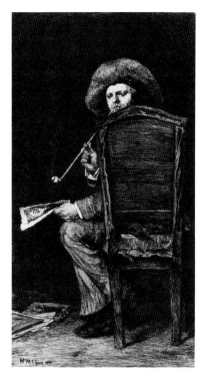

Fig. 27. William Unger, after William Merritt Chase, *Frank Duveneck*, 1875, etching. Private collection

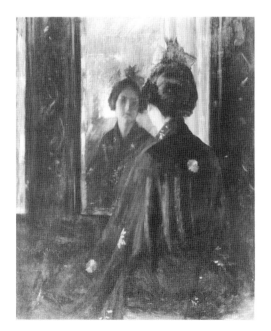

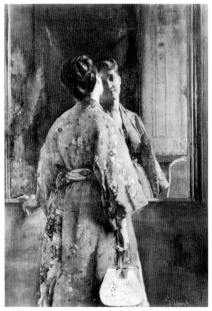

LEFT: Fig. 28. William Merritt Chase, *The Mirror*, about 1900, oil on canvas. Cincinnati Art Museum, Museum Purchase

RIGHT: Fig. 29. Alfred Stevens, *The Japanese Robe*, about 1872. The Metropolitan Museum of Art, New York, Bequest of Catharine Lorillard Wolfe, 1887. Catharine Lorillard Wolfe Collection. (87.15.56)

to it. Chase's *A Friendly Call*, despite the exactness with which it depicted the Shinnecock studio (compare fig. 8), was also profoundly influenced in its conception by a Stevens painting, *The Salon of the Painter* of 1880 (fig. 30). Purchased directly from the artist by William K. Vanderbilt, it, like *The Japanese Robe*, was owned in New York. The relationship between *A Friendly Call* and *The Salon of the Painter* lies not only in the obvious similarity of the central motif of figures conversing on a couch before a mirror that reflects them and the room and windows opposite, but also in the fact that Stevens depicted the salon of his own house as Chase did the domestic space and life of his own studio. To that extent, as Chase probably knew, they depicted the same subject. It is interesting, too, that a version of Stevens' painting was given a title very similar to Chase's: *En Visite*.

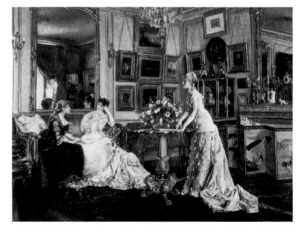

Fig. 30. Alfred Stevens, *The Salon of the Painter*, 1880, oil on canvas. Private collection, Belgium

The Power of Painting and the Nature of Art

Royal Cortissoz wrote of *A Friendly Call* in his review of the 1895 Society of American Artists exhibition:

> It is vivacious in color and in style, the scene is handled briskly, with an authoritative elegance, and its dainty light charm is made the most of with an evident enjoyment of the technical facility needed for the exploitation of such a thin motive. The theme is certainly not a lofty one, yet undoubted ability has gone to this celebration of it, and while its painter may not seem a man of high imagination, he is just as plainly a technician of good taste, one with a feeling for the suave picturesqueness of some social life.[32]

Technically brilliant, but not terribly deep or thoughtful; a mindless, unimaginative, but exceedingly gifted painter of surfaces—this is the standard reading and, insofar as he himself contributed to it, the authorized version of Chase's enterprise. Cortissoz was not the first to describe it; others, over the years, observed the same thing: Chase's "is not so much the art of the brain that thinks or of the imagination that conceives as of the eye that sees and the hand that records," Kenyon Cox wrote in 1889. "His art is objective and external. . . . Whatever the bodily eye can see, Mr. Chase can paint, but with the eye of the imagination he does not see."[33] Chase himself repeatedly argued, in words and paint, for the primacy of technique over subject, and, as he did for so much else, found his belief supported by the example of Velázquez: "People talk about poetical subjects in art," Chase said, "but there are no such things. The only poetry in art is the way an artist applies his pigments to the canvas. A yellow dog

with a tin can tied to his tail would have been enough inspiration for a masterpiece by a consummate genius like Velasquez."[34] And he found support in Stevens, too: "Alfred Stevens' women in ridiculous hoopskirts are still among the ineffably lovely creations of art—all because of the treatment, the technique. It is never the subject of a picture which makes it great; it is the brush treatment, the color, the line. There is no great art without a great technique back of it."[35]

Chase's Shinnecock paintings are, in these terms, the supreme examples in all of his work, early or late, of his powers as a painter and of the power of painting itself to make the commonplace and quotidian beautiful. Their technical brilliance is one of the things that makes them so extraordinarily lovely. But was Chase, after all, only "a technician of good taste" whose art was otherwise barren of conscious and significant meaning, without thought and without subject? His was not, to be sure, imaginative art as the late nineteenth century understood it: Chase did not translate his wife and children into holy families, as Abbott Thayer and George De Forest Brush did (figs. 31, 32); nor did he classicize his figures as even Thomas Eakins did,[36] or give them allegorical meaning. It was not a narrative or literary art, either. But it did have a subject, the richest and profoundest subject of all, so far at least as Chase was concerned—the subject of art itself.

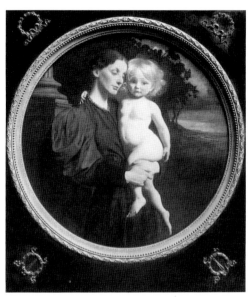

LEFT: Fig. 31. Abbott Henderson Thayer, *Virgin Enthroned*, 1891. National Museum of American Art, Smithsonian Institution, Washington; Gift of John Gellatly

RIGHT: Fig. 32. George De Forest Brush, *Mother and Child*, 1895. Courtesy Museum of Fine Arts, Boston, William Wilkins Warren Fund. 95.1375

Art had always been Chase's subject. Earlier, Chase expounded it publicly; at Shinnecock, he examined it privately. In the Shinnecock interiors, of all his art the most inward, Chase considered the power of painting and the nature of art—what art does, and how it does it—in newly subtle and thoughtful ways, and by the vehicle of painting itself.[37]

A painting of 1892, called simply *A Study* (fig. 33)—perhaps to acknowledge its deliberately investigatory purpose (its "scheme"), though it depicts Chase's wife in the Shinnecock studio—was described by language ("pictured picture") suggesting the essentially pictorial character of the issues it addressed, for which words were imperfect tools of description:

> His scheme for the second picture of the summer was to have his wife sitting before
> the picture just described [*The Fairy Tale* (pl. 1)], her attention from an examina-
> tion of the picture just arrested by a remark from some one behind her, and she
> turning to reply. Here, it will be perceived, was to be in the background a framed
> picture within a picture, the painted gold frame of the pictured picture coming
> very close to the actual gold of the actual picture. . . .[38]

A Study was not the only Shinnecock painting to consider the problem of illusion and reality. A much better one, *Did You Speak to Me?* (fig. 34), operates in the same way to raise the complex issue of that relationship. In both cases the figure in the painting turns suddenly to respond to something said behind her by someone outside the space of the picture itself. This almost theatrical engagement with the beholder crosses and cancels the boundary between painting and reality and the separation, established by pictorial convention and the visual mechanics of painting, between depicted space and real space. It is as if the painting and what is outside it are one and the same, continuous and coextensive.

There is a touch of mere cleverness in this. But by in both cases depicting pictures within pictures, and frames within frames, Chase extended the question of pictorial representation in more serious ways. For if what, by the evidence of sight and logic, is understood to be a depiction—and a depiction, an illusion of something (a painting) that is itself an illusion—is in turn included within a depiction, which is the representation and which the reality? Is the picture more real than the painting it depicts? And if the depicted frame matches the actual frame, as it was said to have done, one is led visually to compare and equate a painted simulation of a frame that is part of a painted illusion with the physical frame existing in real space and that, visually and by convention, marks the frontal and peripheral limits of the pictorial illusion, and is, what is more, the conventional sign of the

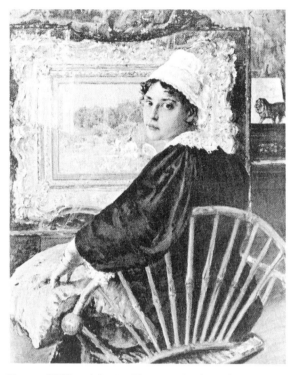

Fig. 33. William Merritt Chase, *A Study*, published in *Harper's Monthly* 87 (June 1893), 9

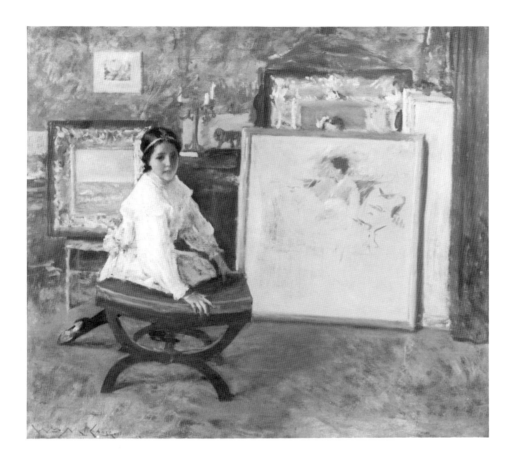

completion—the temporal or procedural conclusion—of that illusion.

In these ways Chase was not making claims for technique ("the way an artist applies his pigments to the canvas"), but for certain more specific operations of *painting*, principally its power, by visual mechanics and by a kind of reasoned visual argument, to create pictorial illusions that in their credibility and by their logic call into question, as a matter for consideration as an aspect of artistic meaning, the distinction, or the lack of it, between art and actuality.

In *Did You Speak to Me?* the argument is enriched by the sketchy beginning of a painting at the right. By its incompletion it is a foil for the completed (framed) illusion of the "pictured picture" at the left, and for the picture that contains them both. At the same time, however, as a representative of artistic process it is a reminder that pictorial illusion is, at its source and in its essence, an act of art.

Fig. 34. William Merritt Chase, *Did You Speak to Me?*, about 1897. The Butler Institute of American Art, Youngstown

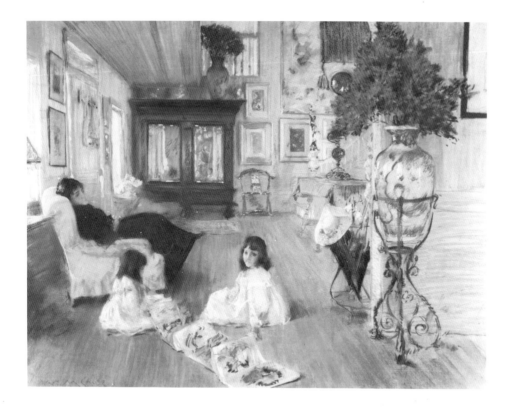

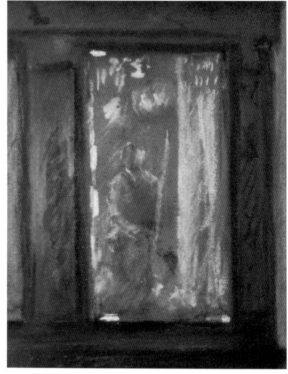

Hall at Shinnecock (fig. 35) and A Friendly Call refer in several ways and for several reasons to Velázquez' Las Meninas (fig. 25). They do so in order to build otherwise thoroughly modern images upon what Chase called "the eternal principles"[39] that governed the great art of the past, and, more specifically, to explore in the terms of modern images the challenge of Velázquez' extraordinary painting. References to Velázquez are made in several ways: Chase's wife and children, like modern maids of honor, correspond loosely in kind and pattern to the figuration of Las Meninas; the mirror image in Hall at Shinnecock is the counterpart of the mirrored reflection of the king and queen in Las Meninas; and the reflected view of the stairs and far room in A Friendly Call is Chase's version of a similar motif in Velázquez. In another and even more interesting reference, Chase's pose reflected in the mirror of Hall at Shinnecock (fig. 36) imitates Velázquez' in Las Meninas. That is, of course, an act of homage on Chase's part to the master he admired above all others. And by showing himself not only in Velázquez' pose but, as Velázquez did in Las Meninas, making art in the very work of

LEFT: Fig. 35. William Merritt Chase, Hall at Shinnecock, 1892 or 1893. Terra Museum of American Art, Chicago; Daniel J. Terra Collection

RIGHT: Fig. 36. Detail, Hall at Shinnecock

art he is making and as part of the very subject that it depicts, Chase, like Velázquez, created an illusion of the most remarkably convincing kind, and one, at the same time, that includes within itself the reminder, in the figure of the working artist, that it is a *painted* illusion.

Mirrors and mirror images appear prominently in a number of the Shinnecock interiors (pls. 18, 20, 21, fig. 28). They appear in them in greater concentration, and with more significance, than in any other group of Chase's work. That is surely because of their special appropriateness for the kinds of things that Chase was concerned to explore, explain, and express.

For in the exploration and explanation of pictorial illusion nothing is as valuable as the mirror. Without assistance or insistence, the mirror invokes the potency, complexity, and ambiguity of illusion; its convincing depiction alone is a self-evident demonstration of the degree of illusion that painting can achieve. And in its capacity, by visual devices rather than theatrical ones, not merely to imply the existence of things outside the picture space but by means of their reflections to depict them, and, moreover, to incorporate within pictorial space the space outside it, as in *Hall at Shinnecock*, *A Friendly Call*, *Reflections*, and *The Mirror*, the mirror virtually compels consideration of the possibilities and problematics of pictorial illusion: No part of Velázquez' *Las Meninas* is as endlessly fascinating and perplexing as the mirror on the far wall that seems to hold the key to the painting's meaning, pictorial operation, and ambition.[40]

But there is something more. As the standard of perfect and complete artistic illusion, the "mirror of nature" was for centuries, archetypically and idiomatically, the emblem of art. It is in its capacity as a symbol, too, that the mirror figured so prominently in Chase's art—the art of someone who, in Kenyon Cox's words, could paint whatever the bodily eye could see—and, for that matter, in the decoration of his house and studio, where mirrors and pictures had equal status (figs. 8, 11).[41]

For the late nineteenth century, however, the mirror was less widely understood as the symbol of art's reflection of outward nature than as the symbol and the instrument of self-reflection and psychological insight— the symbol less of seeing than of the unseen. It is in that capacity also that Chase used it. That, of course, is the meaning and function of the mirror in *Reflections*. Explaining that "The lady is *reflecting* about some matter; we see her face *reflected* in the glass," one critic saw it merely as "a pun in paint."[42] But it was more serious and subtle than that. It represents a state of mind

that touched much of what Chase did at Shinnecock in the 1890s—an interiority that expressed itself variously as privacy of subject matter, analytical thoughtfulness, and psychological awareness—and was, furthermore, no matter how much it derived from the particular conditions of Chase's life in the 1890s, a state of mind that the fin de siècle as a whole found particularly congenial and to the expression of which much of the characteristic visual and literary art of the period was devoted.

As a pictorial invention *Reflections* owed something, as we have noted, to Alfred Stevens' *The Japanese Robe* (fig. 29); but another work by Stevens, to which, so far as we know, *Reflections* owed nothing as a source, is nevertheless a clue to the meaning it and other reflected images like it may have had. Titled *La Psyché* (fig. 37), it depicts a model peering from behind a mirror in which she is partly reflected. The title seems to refer to the large, full-length mirror known in French as a *psyché* (a cheval glass in English). But a true *psyché* or cheval glass can be tilted; in Stevens' painting the mirror is immovably fixed in the easel and is not, in fact, a *psyché* at all. That is not a trivial point, because if the painting's title does not name a specific type of mirror it must name something else. It may be the model, gazing at her own reflection like the mythological Psyche. But it may also be her reflected image itself that is named, the image, as the title indicates, not of her outward appearance but her inner being, her psyche.

In these terms it is possible to think that the difference between Mrs. Chase in *In the Studio* (pl. 17) and Mrs. Chase in *Reflections* is the difference between a depiction of her outward appearance and her mirrored inner self, between her persona and her personality. Seen outwardly in *In the Studio* she is impassive, impenetrable, and surrounded by an array of outwardly reflective fabrics, metals, and polished woods that in their externality reinforce her own. Seen mirrored in *Reflections* her expression is inflected by a wry smile and intent gaze that are the signs of thought and emotion, just as the darkness of the setting and the inward movement into (mirrored) space that the experience of the picture requires reinforce its interiority.

Perhaps it is possible to think similarly of Mrs. Chase's mirrored profile in *A Friendly Call* (fig. 38) as a dark reflection of her inner self surrounding her like a psychological penumbra; and possible, too, perhaps, to think of it as the psychological dimension of the ritual of modern manners that is the painting's nominal subject; for her head is placed before, and its reflection is located within, the mirror in the "deepest" part of the painting. (It is also tempting to think that the charged contrasts and tensive energies in

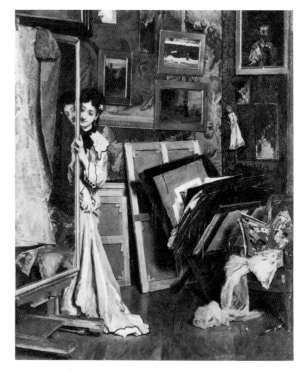

Fig. 37. Alfred Stevens, *La Psyché*, about 1871. Private collection, Belgium

the reflection of Regnault's *Automedon and the Horses of Achilles* surrounding Mrs. Chase's head like a nimbus are a visual metaphor of her thoughts and feelings.)

The painting of Chase's in which the psychological disclosures of the mirror are most compelling, however, is not a Shinnecock interior, though it is the culminating expression of things that happened and first became artistically visible during the Shinnecock years, but Chase's late self-portrait (fig. 3). What Chase, with inwardly penetrating vision, saw in the mirror and what he depicted literally in the portrait and fictively in the painting—the "mirror of nature"—on the easel was not the outward beauty of color and form, but inner darkness, disturbance, and disarray.

For someone who moved in the world as conspicuously as Chase did, who had many friends, was always available to critics, reporters, and photographers, and who taught an army of admiring students, strangely little is known about him. There are plenty of anecdotes and aphorisms, there are some lectures and interviews, some adoring biographies and reminiscences, numerous articles, and not much else—nothing, at any rate, that tells in more than generalities what he thought and believed and felt. But that is so only because transactions with Chase and Chase's art have always taken place within clear and closely guarded limits. It is possible, of course, that we know all there is to know, and that what was said of the superficiality of his art could also be said of him. But his art tells a different story. It is at its best deeper, more complex, ambitious, thoughtful, and expressive by far than it has been customary to allow. For the error in dealing with Chase is not to see too much in his art, but not to see enough of what is there.

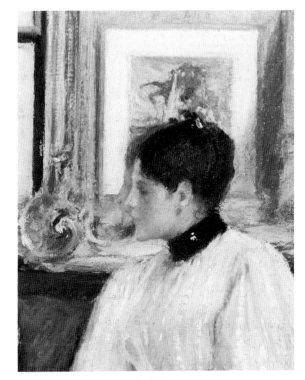

Fig. 38. Detail, *A Friendly Call*

Notes

1. "Art and Artists of New York," *The Independent* 33 (21 April 1881), 188.

2. John C. Van Dyck, *American Painting and Its Tradition* (New York, 1919), 188.

3. "The Chase Collection," *New York Tribune* (3 January 1896).

4. *The Art Interchange* 33 (August 1894), 43.

5. "Mr. Chase has probably been exploited in the newspapers more than any other American artist, with the exception of Mr. Whistler, if we may claim the latter as a countryman." "The Collection of William Merritt Chase," *The New York Times* (3 January 1896).

6. Philip Poindexter, "A Foremost American Painter," *Leslie's Weekly* 80 (16 May 1895), 319.

7. Ishmael, "Through the New York Studios. IV. William Merritt Chase," *The Illustrated American* 5 (14 February 1891), 616.

8. "Chase's Famous Studio," *Leslie's Weekly* 82 (16 January 1896), 41.

9. Poindexter 1895, 319.

10. As a writer for the *New York Times* sensed: "How this able artist could bring himself to part with this delightful houseful of beautiful things is no matter of the public's concern, and yet the thought will not down, for the dispersal of these interesting trophies of travel, of research, and good taste seems positively pitiful when the studio itself is recalled, and one remembers how each separate piece seemed to be a part and parcel of a harmonious and picturesque whole" (5 January 1896).

11. John Gilmer Speed, "An Artist's Summer Vacation," *Harper's New Monthly Magazine* 87 (June 1893), 5.

12. Leland M. Roth, *The Architecture of McKim, Mead & White 1870–1920: A Building List* (New York, 1978), 23, 41.

13. "William Merritt Chase . . . has spent most of the summer down on Long Island, at The Inn, Shinnecock Hills. . . ." "In Gotham's Studios," *New York World* (27 September 1891).

14. Speed 1893, 5. Emphasis is the author's.

15. Speed 1893, 5.

16. Speed 1893, 10.

17. In Philip Poindexter, "The Shinnecock Art School," *Leslie's Weekly* 75 (29 September 1892), 224; later reproduced in *Demorest's Family Magazine* 33 (April 1897), 308.

18. Speed 1893, 5.

19. Speed 1893, 10. "Another interesting picture of the summer was a pastel study of the hallway of the artist's house with a group of his family."

20. Poindexter 1895, 321.

21. Walter Muir Whitehall, *Museum of Fine Arts, Boston: A Centennial History* (Cam-

bridge, Mass., 1970), 1:78–81.

22. In Royal Cortissoz, "Spring Art Exhibitions. The Society of American Artists," *Harper's Weekly* 39 (6 April 1895), 316.

23. Speed 1893, 7.

24. "Talk by William Merritt Chase," *Art Interchange* 39 (December 1897), 127.

25. William Merritt Chase, "Velasquez," *The Quartier Latin* 1 (July 1896), 4.

26. "The Import of Art. By William M. Chase. An Interview with Walter Pach," *The Outlook* 95 (25 June 1910), 442.

27. Outlook 1910, 442.

28. Outlook 1910, 442.

29. Outlook 1910, 442.

30. For Stevens and the paintings herein considered see William A. Coles, *Alfred Stevens* [exh. cat., The University of Michigan Museum of Art] (Ann Arbor, 1977).

31. The kimono is perhaps the one seen hanging from the corner of a frame in the Shinnecock studio at the left of fig. 7.

32. Cortissoz 1895, 318.

33. Kenyon Cox, "William M. Chase, Painter," *Harper's New Monthly Magazine* 78 (March 1889), 549, 552.

34. Perriton Maxwell, "William Merritt Chase—Artist, Wit and Philosopher," *The Saturday Evening Post* 172 (4 November 1899), 347.

35. Maxwell 1899, 347.

36. As in *An Arcadian*, probably 1883. Reproduced in Lloyd Goodrich, *Thomas Eakins* (Cambridge, Mass., 1982), 232, no. 103.

37. Kenyon Cox had noted earlier that Chase was "contented to set himself delightful and not insoluble problems of rendition, and [drew] infinite pleasure from their resolution." (Cox 1889, 554).

38. Speed 1893, 6.

39. Outlook 1910, 442.

40. For a recent discussion of *Las Meninas* and the problems of its interpretation, see Jonathan Brown, *Velázquez: Painter and Courtier* (New Haven and London, 1986), 253–264.

41. The round convex mirror hanging in the stairway of the central hall at Shinnecock (fig. 11) is particularly interesting because it was a type of mirror, as Heinrich Schwarz has shown, that "by the end of the fifteenth century or earlier . . . actually belonged to the common inventory of a well equipped workshop." "The Mirror of the Artist and the Mirror of the Devout," *Studies in the History of Art Dedicated to William E. Suida on His Eightieth Birthday* ([London], 1959), 94.

42. "The Exhibition of the Society of American Artists," *The Art Amateur* 30 (April, 1894), 127.

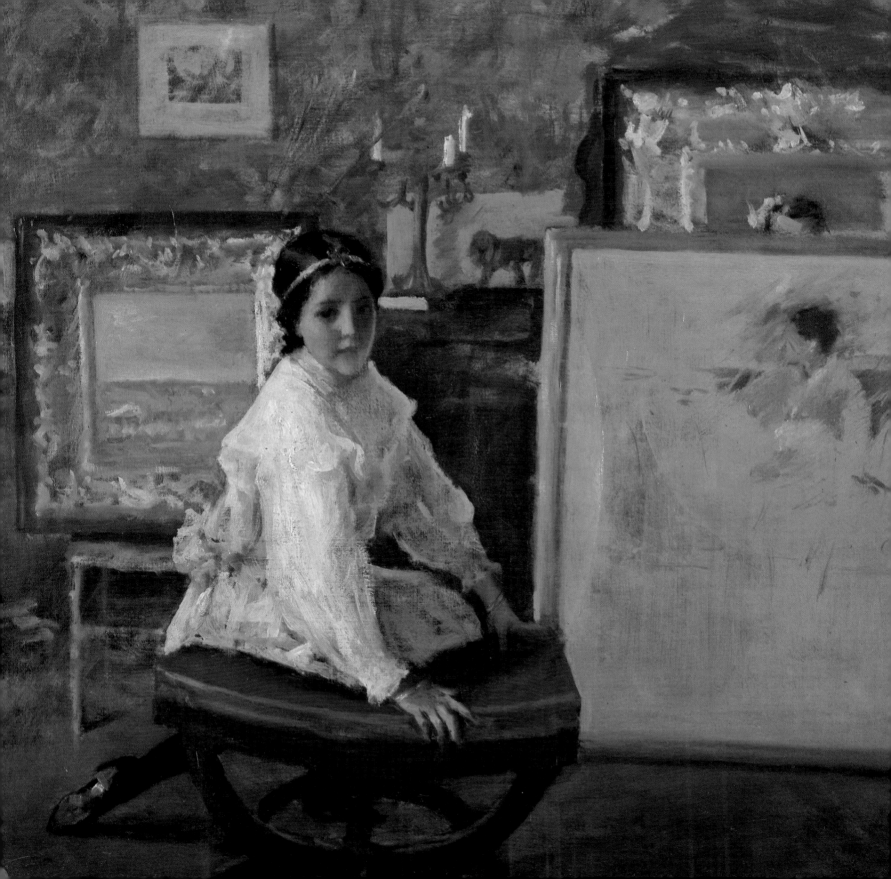

Plates

Landscapes

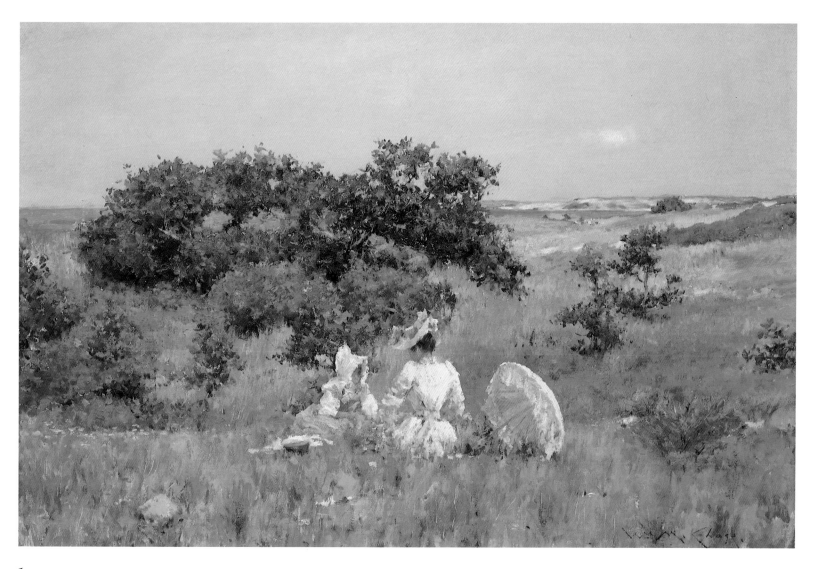

1
The Fairy Tale, 1892
oil on canvas, .41 × .61 m (16 × 24 in.)
Collection of Mr. and Mrs. Raymond J. Horowitz
(SHOWN IN WASHINGTON ONLY)

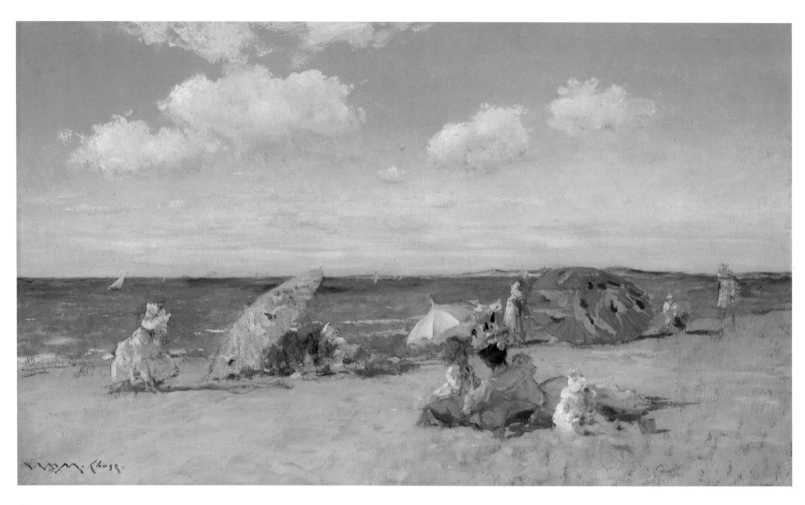

2

At the Seaside, about 1892

oil on canvas, .51 × .86 m (20 × 34 in.)

Lent by The Metropolitan Museum of Art, New York;

Bequest of Miss Adelaide Milton de Groot, 1967

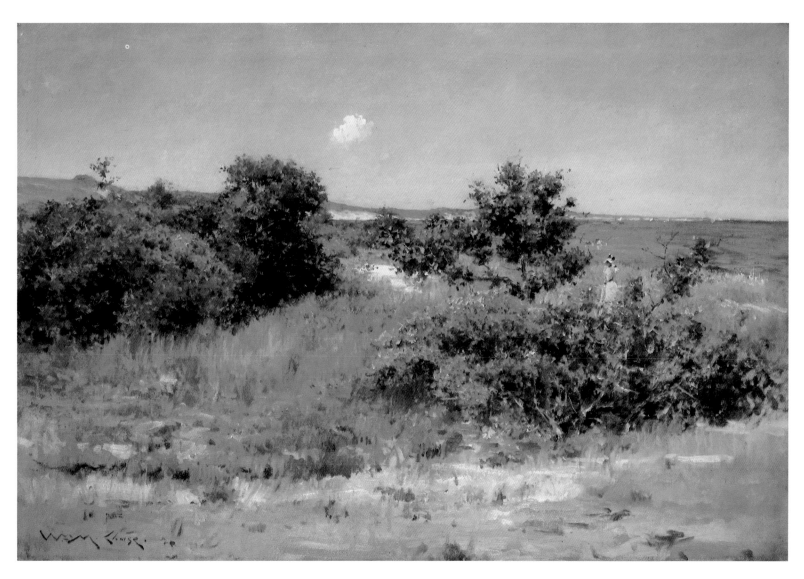

3
Shinnecock Hills, Peconic Bay, about 1892
oil on canvas, .60 × .89 m (24 × 35 in.)
Jamee and Marshall Field

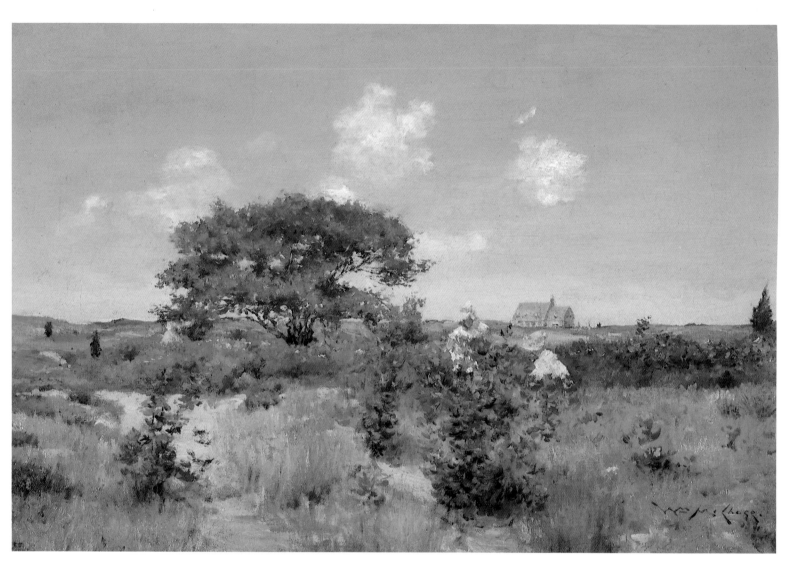

4
Untitled (Shinnecock Landscape), about 1892
oil on canvas, .41 × .61 m (16 × 24 in.)
The Parrish Art Museum, Southampton

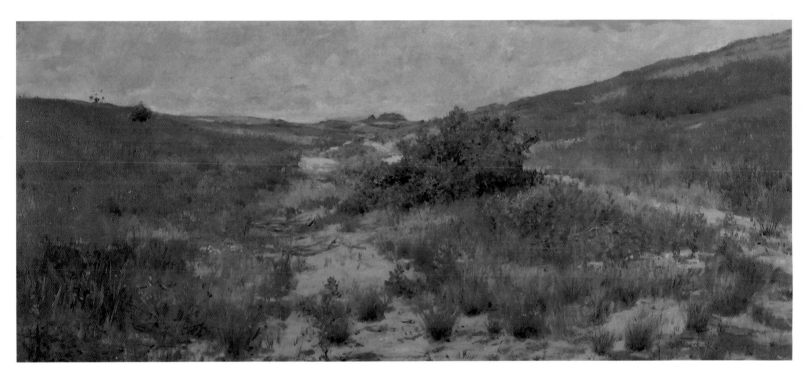

5
Shinnecock Hills, about 1892
oil on canvas, .51 × 1.18 m (20 × 46 in.)
Georgia Museum of Art, The University of Georgia, Athens,
Eva Underhill Holbrook Memorial Collection of American Art,
Gift of Alfred H. Holbrook, 1945

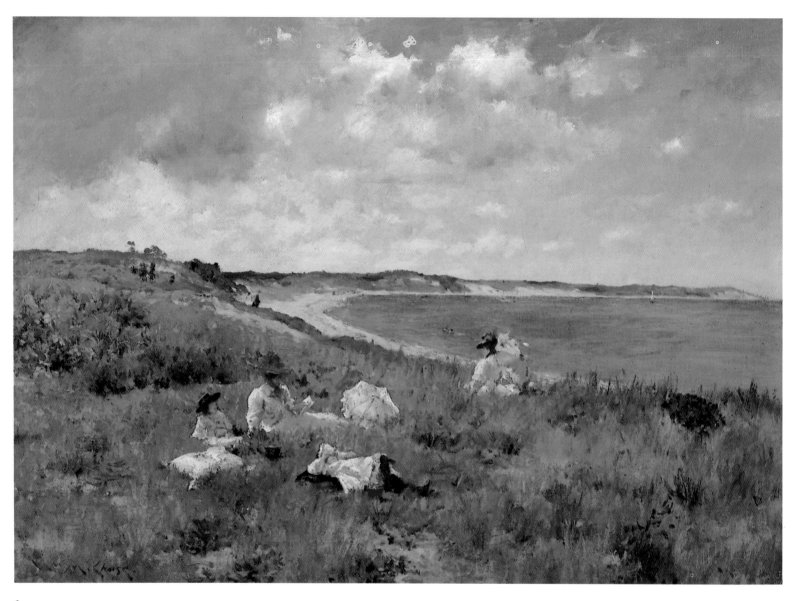

6
Idle Hours, 1894 or 1895
oil on canvas, .64 × .89 m (25 × 35 in.)
Amon Carter Museum, Fort Worth

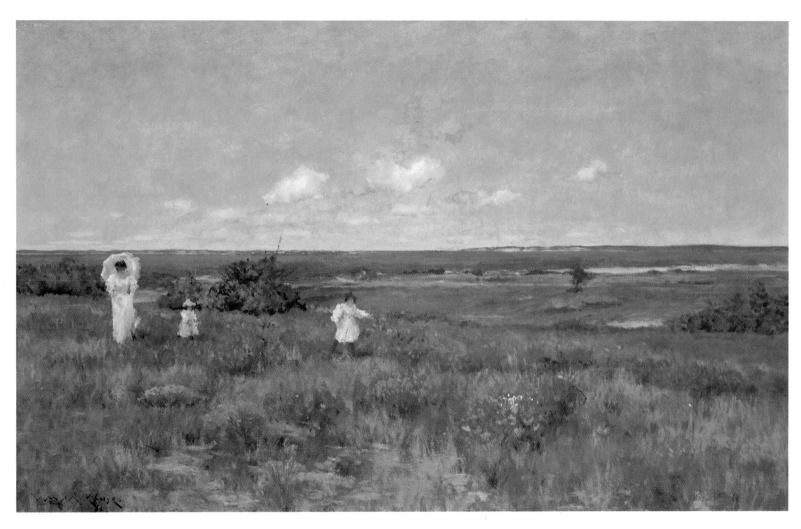

7
Near the Beach, Shinnecock, about 1895
oil on canvas, .76 × 1.23 m (30 × 48 in.)
Toledo Museum of Art; Gift of Florence Scott Libbey

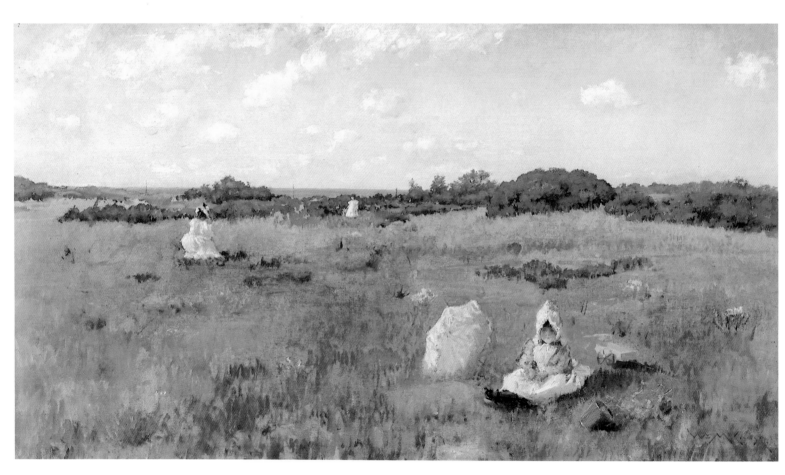

8
Gathering Autumn Flowers, 1894 or 1895
oil on canvas, .53 × .97 m (21 × 38 in.)
From the Collection of Mr. and Mrs. Paul Mellon,
Upperville, Virginia

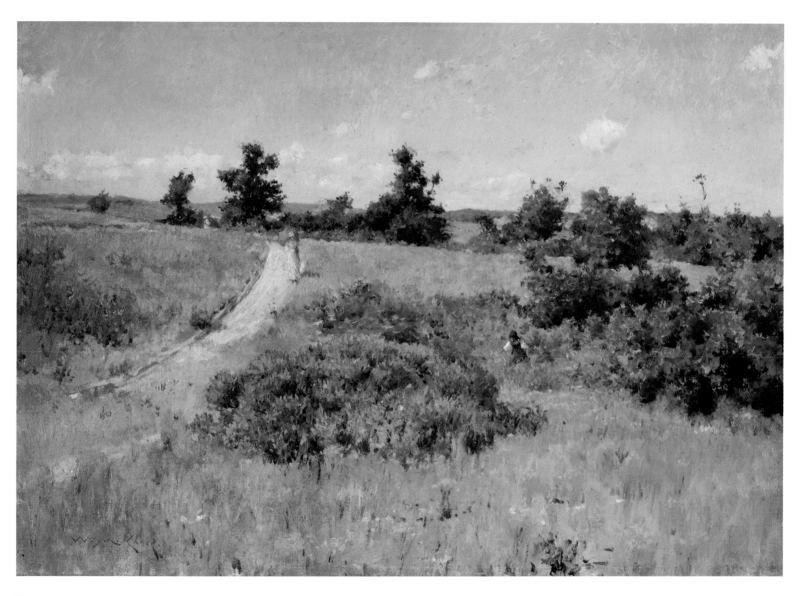

9
Shinnecock Landscape with Figures, about 1895
oil on canvas, .58 × .83 m (23 × 32¾ in.)
Murjani Collection

10
Shinnecock Hills, about 1895
oil on canvas, .86 × 1.02 m (34 × 40 in.)
Lent by National Museum of American Art,
Smithsonian Institution, Washington, Gift of William T. Evans

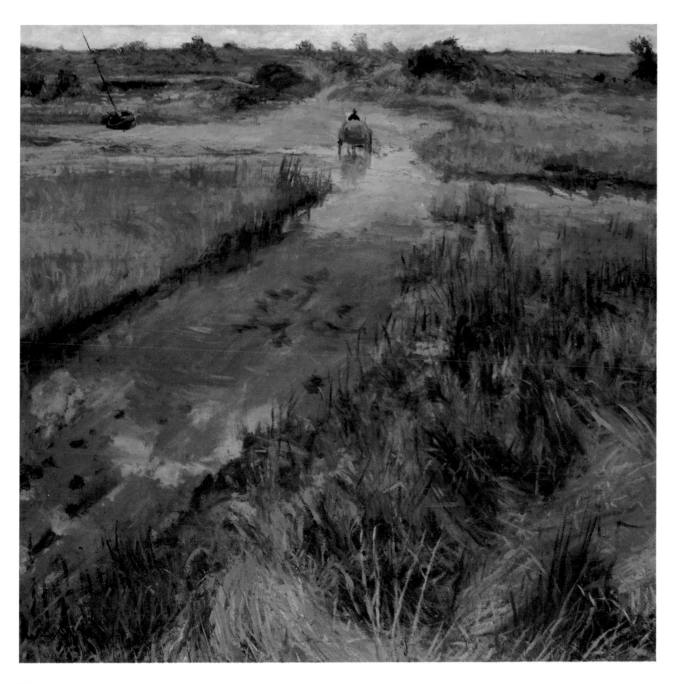

11
Swollen Stream at Shinnecock, about 1895
oil on canvas, 1.12 × 1.17 m (44 × 46 in.)
Private collection

12
Shinnecock Hills, about 1895
oil on canvas, .89 × 1.02 m (35 × 40 in.)
Private collection

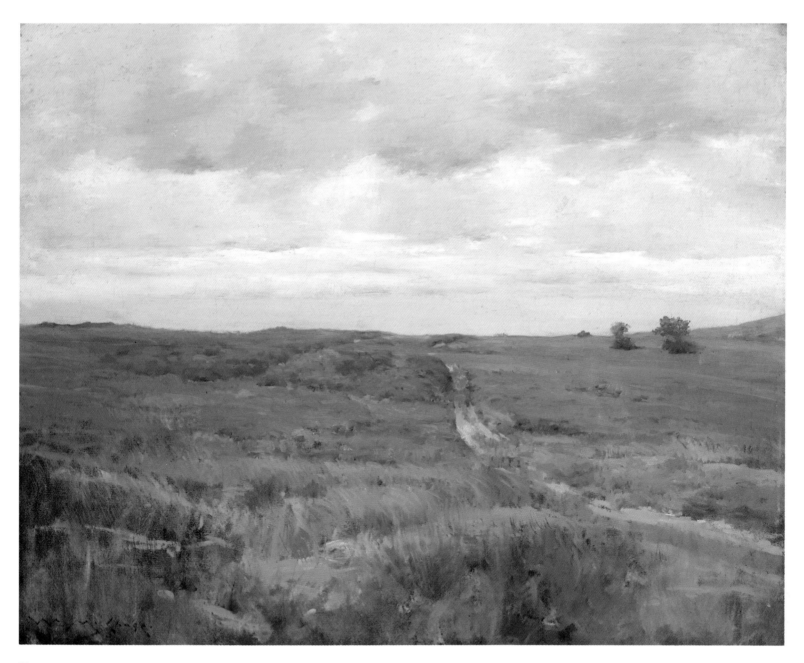

13
Over the Hills and Far Away, about 1897
oil on canvas, .65 × .73 m (25 × 32 in.)
Henry Art Gallery, University of Washington, Seattle,
Horace G. Henry Collection

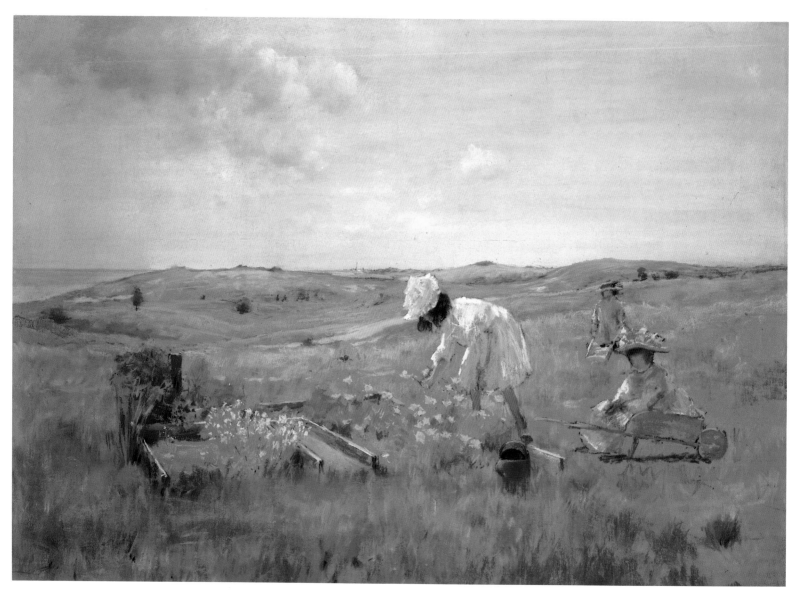

14
Gathering Flowers, about 1897
pastel on canvas, .69 × .94 m (27 × 37 in.)
From the Collection of Mr. and Mrs. Paul Mellon,
Upperville, Virginia

Interiors

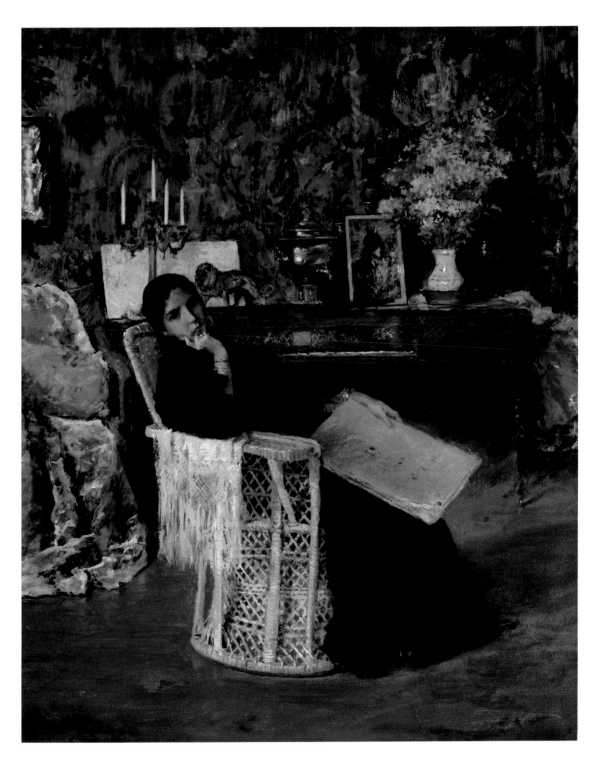

17
In the Studio, 1892
oil on canvas,
.74 × .58 m (29 × 23 in.)
Mr. and Mrs. Arthur Altschul

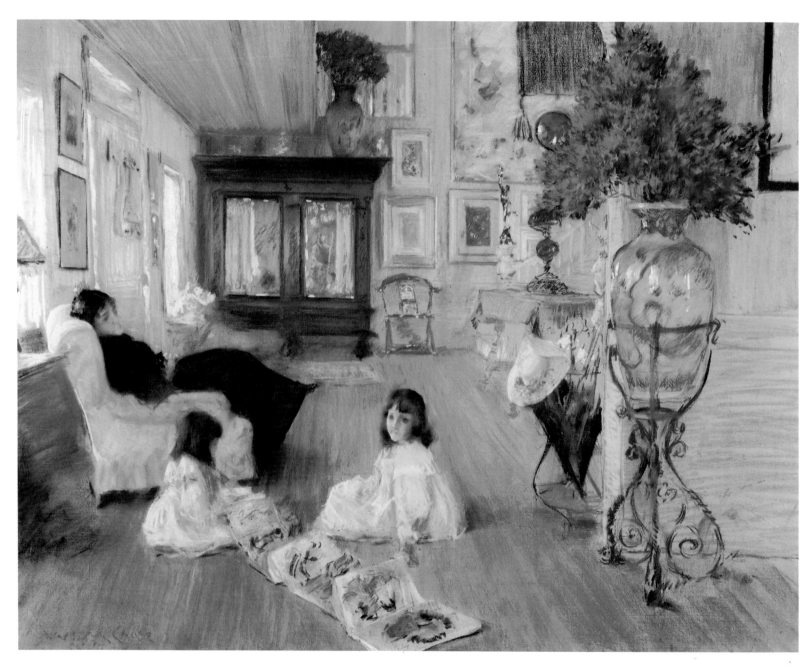

18
Hall at Shinnecock, 1892 or 1893
pastel on canvas, .81 × 1.04 m (32 × 41 in.)
Terra Museum of American Art, Chicago; Daniel J. Terra Collection

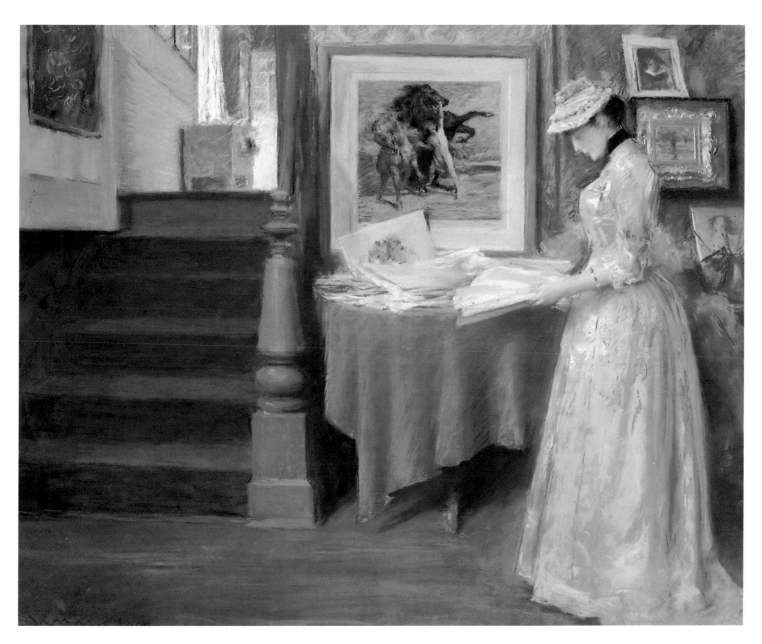

19
In the Studio (Interior: Young Woman at a Table), 1892 or 1893
pastel on paperboard, .56 × .71 m (22 × 28 in.)
Hirshhorn Museum and Sculpture Garden,
Smithsonian Institution, Washington, Gift of Joseph H. Hirshhorn, 1966
(SHOWN IN WASHINGTON ONLY)

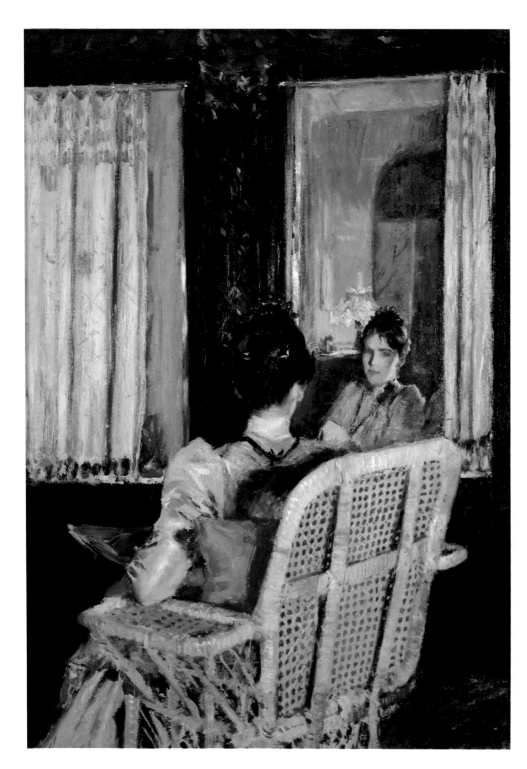

20
Reflections, about 1893
oil on canvas, .64 × .46 m (25 × 18 in.)
Collection of Mr. and
Mrs. Raymond J. Horowitz
(SHOWN IN WASHINGTON ONLY)

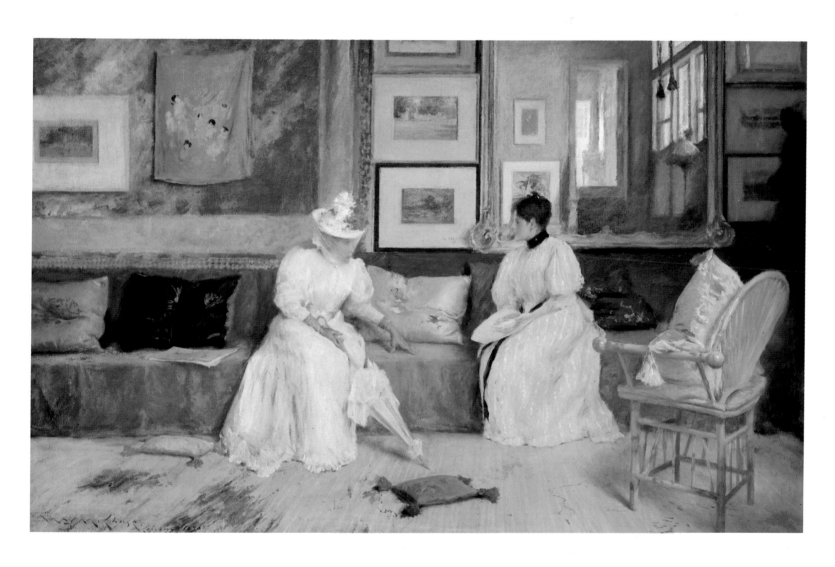

21
A Friendly Call, 1894 or 1895
oil on canvas, .77 × 1.23 m (30⅛ × 48¼ in.)
National Gallery of Art, Washington, Chester Dale Collection
(SHOWN IN WASHINGTON ONLY)

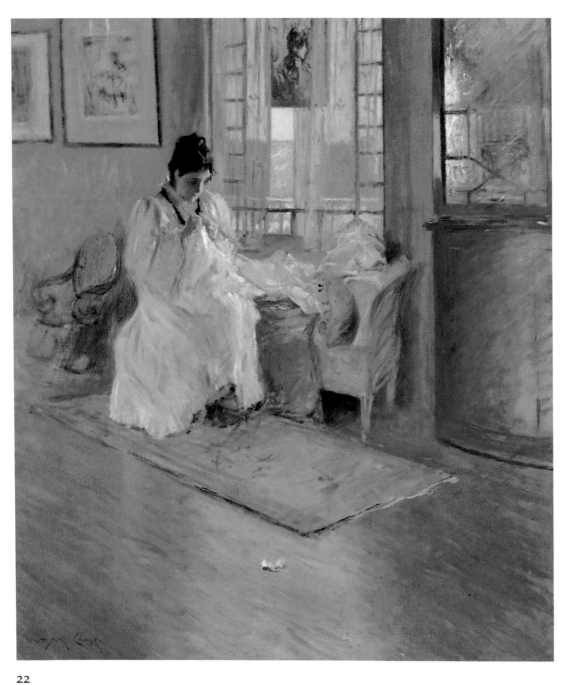

22

For the Little One, about 1896

oil on canvas, 1.02 × .89 m (40 × 35 in.)

Lent by The Metropolitan Museum of Art, New York; Amelia B. Lazarus Fund by exchange, 1917 (13.90)

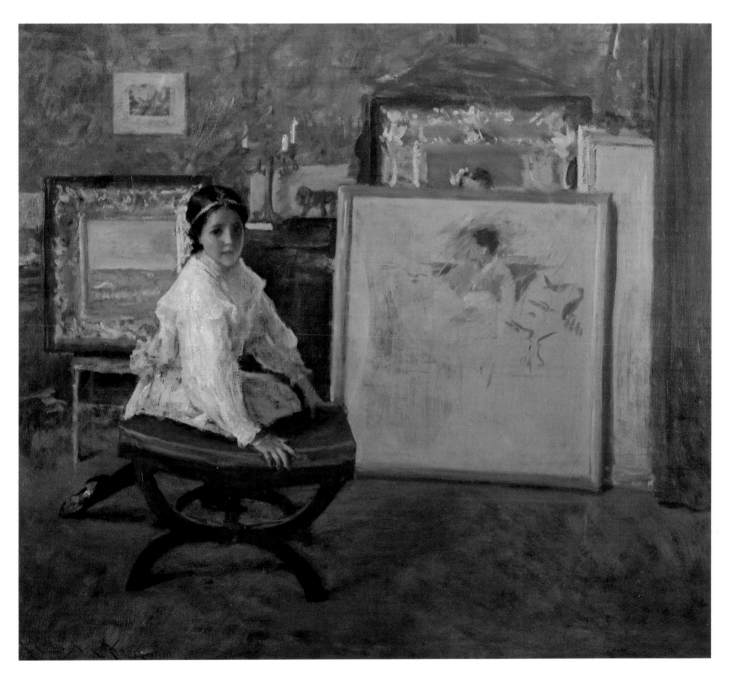

23
Did You Speak to Me?, about 1897
oil on canvas, .91 × 1.04 m (36 × 41 in.)
The Butler Institute of American Art, Youngstown

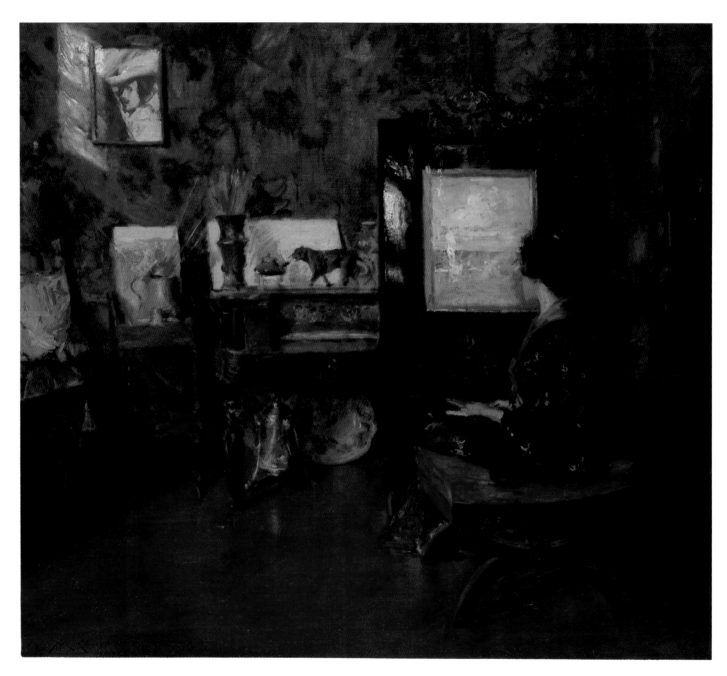

24
Alice in the Shinnecock Studio, about 1901
oil on canvas, .97 × 1.09 m (38 × 43 in.)
The Parrish Art Museum, Southampton, Littlejohn Collection

Select Bibliography

Gerdts, William H. *American Impressionism*. New York, 1984.

Pisano, Ronald G. *A Leading Spirit in American Art: William Merritt Chase 1849–1916*. Seattle, 1983.

Pisano, Ronald G. *William Merritt Chase*. New York, 1979.

Pisano, Ronald G. *William Merritt Chase in the Company of Friends*. Exh. cat., The Parrish Art Museum, Southampton, 1979.

Roof, Katharine Metcalf. *The Life and Art of William Merritt Chase*. 1917. Reprint. New York, 1975.

The Students of William Merritt Chase. Essays by Ronald G. Pisano. Exh. cat., Heckscher Museum, Huntington, New York, 1973.

William Merritt Chase. Exh. cat., The Art Gallery, University of California, Santa Barbara, 1964.